T. A. McM[

Gathering

Courage

A Life-Changing Journey Through

Adoption, Adversity, and A Reading Disability

Encouragment
does make
a
difference — TMc 182
2017

Gathering Courage

T. A. McMullin © 2015

The stories and interviews in this book are true although the names and identifiable characteristics have been changed to maintain confidentiality and privacy. In describing the events in this memoir, the sequence of events have been compressed and some details have been changed to assist the narrative. Where exchange of dialogue appears, the intention was to bring forth the essence of the conversation rather than verbatim quotes.

For more information about speaking engagements, book purchases, discount bulk sales or for purchases by churches, corporations, non-profit groups, or educational organizations please contact:

T. A. McMullin

GatheringCourageMedia@gmail.com

GatheringCourageMedia.com

Print ISBN: 978-0-9967113-0-2

eBook ISBN: 978-0-9967113-1-9

Pictures of the backcountry of Wyoming by Sally J. Wulbrecht

Cover - Snake River - Grand Teton National Park Wyoming by Sally J. Wulbrecht

Picture of Gus and Sierra Wimpy Te "Marty Joe," Terry and King Doc Bar Olena "Sonny" by Misti M. Moser

Published by Gathering Courage Media

Dedication

"Life At Its Best Is Tough" is what Fifi Faust always told me.
Hard times come to all of us in a different form or fashion.
How we handle the hard times is what our journey
through life is all about.

This book is dedicated to those who understand what it is like to be in a tough situation. May the story of my life be an encouragement to you so that you will know that struggles can be turned into success and that living a life of compassion and purpose is gratifying and rewarding.

To the many teachers and mentors all across the world:

- ♦ Your knowledge and understanding does make a difference in those you work with and teach.
- ♦ Your continued effort can help turn weaknesses into strengths and desires into accomplishments.

To those who are willing to make life better:

- ♦ Your encouragement does make a difference.
- ♦ Your encouragement puts love in the heart and direction in the dream.

To those adoptive and foster parents:

- ♦ Thank you for opening your hearts and homes with unselfish love for a child in need.
- ♦ Thank you for encouraging a child to succeed and helping them to replace a negative foundation with a positive future.

My heart-felt gratitude goes to each of you for your acts of kindness. One person can make a difference.

"I am proof that one act of kindness can change another person's life."

"Gathering Courage" by T.A. McMullin is an American Story filled with adversity, triumphs, heartbreaks and great personal victory.

T.A. McMullin will transport your mind through the epic words of a female pioneer who never gives up no matter the challenges she faced!

I give this epic book five stars. I held my breath after every chapter, and you will, too!

Charmaine Caraway – The Visionary Woman

Thank you so much for writing "Gathering Courage." I couldn't put your book down... one of the most inspiring books I've ever read.

-Linda

Overall, this memoir is a testament to the endurance of the human spirit in the face of emotional and physical pain... A heartfelt work that takes its time conveying lessons of pain and kindness... Readers will feel as if they're walking alongside McMullin as she tells her story and advises readers how they, too, can survive setbacks.

-KIRKUS Review

"*Gathering Courage* to make life better,

to work hard to follow your *dreams*,

to invest in yourself and others,

to *encourage* others to be their best,

will make life *better*."

T. A. McMullin

Contents

Prologue

THE DUST ROSE UP from the dimly lit arena floor as the sounds of horses filled the air. I stood next to the holding pen as they crowded through the open gate to run at full speed on the arena floor. The horses circled, snorting and bucking, making their presence known. This was a big event for these beautiful horses at the Will Rogers Coliseum in Fort Worth, Texas. Their story was going to be told across the nation with the filming of a special program by National Geographic Wild. It would focus on the mustangs, their inheritance, and the transformation of a wild mustang into a fully broke horse. I watched in total amazement as the arena lights intensified to a full brightness, revealing the cameras set up in the stands. The spectators rose to their feet as the mustangs gathered together after their grand entrance. We all knew this would be a remarkable performance.

The wild horse of the North American plains holds a special place in my heart. In their native habitat, these mustangs had to find their own food, seek shelter from the rain, and always on alert to the dangers found in the wild. Freely roaming on open range only a few months before, they had been rescued, adopted, and given only one hundred and twenty days of training prior to the Fort Worth event. These beautiful, majestic equines were shown love, guidance, trust, and respect from the trainer who worked with them, and now we would see the results.

The desire to train a horse comes from deep within. It takes a person with true inward honesty and an abundant amount of patience to successfully train a horse. An innate awareness of how to work with an animal's natural strength along with the ability to turn fear into courage makes a good trainer great.

Mustangs in holding pen waiting for grand entrance into arena for the filming by National Geographic Wild. Fort Worth, Texas. T. A. McMullin.

Over the next two days in Fort Worth, horse trainers from all over the United States performed with their mustangs in an exhibition sponsored by the Mustang Heritage Foundation. Thousands cheered and watched in awe as formerly wild horses maneuvered through amazing patterns and freestyle movements. Each performance was as different as the color of the horses but a common thread of trust, respect, bonding, and unconditional love between horse and trainer was apparent. I stood, cheered, clapped, and hollered for each horse and for the positive relationship and invisible connection that had developed. It was evident to me that each horse had found peace in a domesticated environment away from his natural habitat in the wild. A new partnership and a strong bond between horse and human had formed. Each horse and trainer was a winner to me.

After the awards were given out and the crowd settled down, the auction began. This was the part that pulled at my heart and exposed

my emotions. Horses and their trainers were scattered throughout the arena. Trainers were waiting for their horses turn to come up for bid. The auctioneer stood in the middle of the arena and with a microphone in his hand, set the pace, and started the bidding.

Jesse, the horse that won first place, was up for bid, meaning he would have a new home, a new environment, and a new owner. All eyes were on this horse and rider who were walking around in the center of the arena. One thousand, fifteen hundred, two thousand, yes, two thousand echoed around the arena and into the stands. Three thousand, yes, three thousand caused the crowd to clap and cheer. Thirty-five hundred, do I hear thirty-five hundred? Yes, now, four thousand, four thousand. Do I hear four thousand?

The auctioneer said in a much slower tone, "This is a solid, well broke horse that will give you his all. Jesse's trainer, Cody, won first place this year and first place last year at the Mustang Million. This horse is as true as the day is long. Do I hear four thousand? Yes, now, let's go for five thousand. Do I hear five thousand?"

The yelling of five thousand bounced from one side of the arena to the other. Then a complete hush came over the crowd as the focus was on Cody. While still mounted on his mustang, Cody pulled his bid card out of his vest pocket and flashed his number at the auctioneer.

"Yes, five thousand, five thousand, do I hear fifty-five hundred?" The sound from the auctioneer intensified throughout the coliseum.

The crowd stared in amazement as Cody kept his bid card raised high in the air. The auctioneer called fifty-five hundred but no one said a word. Cody kept his bid card raised before the auctioneer.

We knew the bond between this horse and trainer was fused solid. Again, the auctioneer loudly called fifty-five hundred but no other bids were raised. No one wanted to take Cody's horse away from him.

"Sold! Sold to Cody Kyle Carson for fifty-five hundred dollars!"

The crowd stood up and cheered to congratulate Cody and Jesse for a job well done. I cried with joy knowing this beautiful, loyal mustang gelding would not be separated from the trainer who taught him how to trust. Cody would not be separated from the horse he loved unconditionally.

Although the auction was over, the emotions prompted by thoughts of separation sat deep in my stomach because I, like Jesse the mustang, had been adopted and placed in a different environment. As a child, the raising and the guidance that I received was turbulent and unsettling. Unconditional love, patience, and trust—experienced by all the performing mustangs at the event— were not a part of my adopted family. I was left to cope on my own to develop the skills needed to be successful in life.

Life circumstances consistently proved to me that not everyone could be trusted. So at an early age, I learned to trust myself and to be self-reliant in order to simply survive. Trust is built one step at a time unfortunately, and the threads of trust can be pulled apart in an instant, with the repair process taking years to rebuild, if it rebuilds at all. Through the love of animals, I realized that kindness and gentleness were life changing. I learned that unconditional love, unconditional trust can melt away hurt and pain hidden deep inside one's being. Love can become a source of encouragement to others.

From the time I was a child, I had an unspoken yearning to be faithful to the Lord. I prayed a lot and held on to what was solid and true. From my heart, I wrote a prayer and repeated it often:

Lord, I want to be what You want me to be...
I want You to be proud of me...
Lord, help me walk through the valley so low to the top of the highest hill.
Lord, I want to travel the journey You set before me.
Please hold my hand and help me to live in the center of Your will.
I need You, Lord, and I want You to be proud of me.

Each of us has a journey to share, a life full of excitement, challenges to be conquered, dreams to be fulfilled, and hard-earned wisdom to be passed along. *Gathering Courage* is my story, my journal, my struggles, and my accomplishments. I share with you my heart-filled life to serve one purpose—to encourage you to be the best you can be. Life at its best is tough and it is in the tough times that we all must gather the courage to be our best and to do our best.

It is my desire that this book will encourage you to reflect on your life, to overcome your hardships, and to accomplish your dreams. The journey is within and I look forward to hearing from you about the courage and accomplishments in your own life.

T. A. McMullin

6

Chapter 1

Life Begins

MY BIRTH MOTHER WAS 25 YEARS OLD when she fell in love with a married man. These two people sang and played musical instruments together in a western band. They were not strangers. However, together they broke a bond of trust, promises made at a wedding, and a commitment to purity. Their lack of self-control, their wild lust for each other, illustrated how one single woman and one married man came together out of wedlock to create an unspoken situation.

So, in the summer of 1954, I was born in a county hospital in Fort Worth, a city in Texas whose slogan is "Where the West Begins." There were no family members present to hold me. There were no smiles for joy and happiness. There was no baby crib in a decorated room awaiting my arrival. There was no family there to cheer and clap for my birth. My birth mother may have heard my first cry but she never saw my face and she never touched me. A few days later, my birth mother was delivered to the bus station in Fort Worth, where she boarded a bus to travel back to wherever she came from. I was delivered to an orphanage, because neither parent wanted me.

The orphanage was nestled in an old, established Fort Worth community where grandmotherly type volunteers went from crib to crib, rocking and feeding newborn babies. My crib was a used wooden cradle. The name Kaysia was printed on a piece of masking tape on the side of the cradle. Kaysia was the beginning of my new identity. The only written family history provided for me was the age of both my natural parents, a little medical history about my maternal grandmother, and that was it. Nothing was stated about my father

except for the fact that he was 24 years of age. My destiny fell under the rules and regulations of the Texas Children's Home and Aid Society, better known as The Edna Gladney Home.

Mrs. Gladney was the superintendent of the facility and selected the proper placement for each of the orphans. Depending on the circumstances, some children went to permanent homes and some were placed in foster homes. A caseworker checked out each home prior to child placement and then six months after placement followed up with another home visit. Questions such as income status, job history, siblings, number of children, health conditions, and home environment, along with personal characteristics such as height, weight, eye, and hair color were asked. The caseworker even talked with other children in the home to determine if they would be accepting of an adopted sibling. After a child was born, Mrs. Gladney would match child to family and family to child before making a phone call to let the new parents know their child was ready for adoption.

Mrs. Gladney matched me with a family six hours away from Fort Worth. The interview and home visit indicated that this family could take care of me and provide me with a good stable home life. Twelve days after my birth, the long awaited phone call by Mrs. Gladney was made to my soon-to-be adoptive parents, informing them that I was ready for my new home.

Upon arrival in Fort Worth, my new parents paid the thirty-four hundred dollar adoption fee, hospital expenses, dental bill, room/board, phone calls, and the bus fare for my birth mother to travel back to her family. My birth mother had left her job and home environment 140 days before I was born to live in the mother care section of the orphanage home. The Gladney Home provided her a safe haven while expecting a child, a place to be out of sight and out of mind from people who knew her.

Gathering Courage

In preparation for my trip to my new home, I was dressed in a plain white infant gown, little white socks, and wrapped in a pink blanket. After the fee was paid, Mrs. Gladney handed me over to my new parents. She personally spoke to them, telling them about the circumstances that caused me to be given up for adoption. After lots of hugs and kisses, I was ready to go home.

My mother held me in her arms as my father drove us home. I was told many times about my arrival and shown pictures of the people who were anxiously waiting. My grandmother, sister, friends, and neighbors were standing in front of the house as the car pulled up and stopped. The front yard was filled with excitement and baby talk. Pink balloons were hanging from the trees. Each person there wanted to hold and kiss me. After the greetings were done and I was changed and fed, my grandmother placed me in a new baby crib and prayed that I would grow up to be a strong, God-fearing, and courageous woman. She asked God to bless me and keep me safe. A young, tricolored Border Collie puppy named Topper settled down on the floor at the foot of my crib.

My beginning with Edna Gladney in the orphanage was over and the present and future were ahead.

Pictures from my early childhood indicate I was loved and enjoyed by various members of my adoptive family. The early years were full of learning, singing, dancing, and playing with animals. I was a happy child. We had horses, a place in the country with a shared interest in the horse barns, riding arenas, golf course, swimming pool, and a clubhouse. I especially enjoyed being at the barn with the horses. I bonded with the animals because they loved me unconditionally.

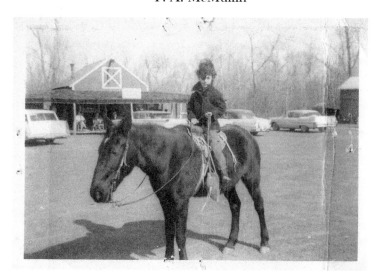

Terry, age 5, after eye injury, riding Ole Joe.

My riding career started at the age of two with a horse called Old Joe. I would ride him in the arena for hours at his chosen pace-slow and slower. But for a two-year-old child, that was perfect. I loved that horse and he loved me. Joe especially loved my carrots. I rode him every weekend for many years. He seemed to understand my eye injury and limited sight that was the result of an eye ulcer.

Horses brought me a sense of belonging to a family. My mother and grandmother would sit by the side of the arena on the front porch of the bunkhouse while I rode Old Joe. They enjoyed their time together just talking and drinking coffee. When my sister, Lindsey, was not with her friends, she on occasion would ride in the arena with me. Because of our twelve-year age difference, however, she was more interested in being with her friends and playing tennis than she was being with me.

My father would play a round of golf before saddling his horse. As I grew older and became more experienced with horses, he and I would ride together, side by side, along the banks of the Brazos River. I was so happy and proud to ride with my father. When I was not

riding, I was sitting tall next to the ranch hand on a buckboard wagon being pulled by a team of mules. Quite often, I was allowed to hold the reins as we drove around the big lake. We would stop the wagon and just look at the ripples on the water made by the fish. At the early age of four, I wondered where did the ripples start and where did they end. I loved being outdoors and in the country. It brought peace into my being.

Back at home in the city was not as peaceful as it was in the country because the blending of our family members created a pull from one child to another. Lindsey's father, Robert, was my mother's first husband. They divorced when Lindsey was about ten years old. Robert was a successful man financially and took care of Lindsey's needs, wants, and desires. He also provided her with money for a car, college, and a wedding. Mr. Robert, as I was allowed to call him, would come to the house several times a year to visit his daughter. He would sit in the living room and visit with the family just like he was a close relative. His wealth and upper class standing was much greater than ours but he was never showy about his financial means. Mr. Robert died an untimely death due to health issues when my sister was sixteen years old.

When I was around three and Lindsey was fifteen, Oliver James was born into our family." Over the years, Oliver was told many times that he was the only natural child in the family. From an early age, he was led to believe he was superior. He basically kept his distance from me, especially as he got older. I don't remember us ever talking, playing, or laughing together as children. We never rode horses together, as he was not interested in learning how to ride. Oliver preferred to be inside reading a book or building a model airplane.

My father worked hard when we were young and made a good living. But as time passed on, by the time I was about seven years of age, my father had many opportunities to be successful but made poor business decisions which often left the family struggling financially. When things got really bad, our horses were sold and the saddles just

seemed to disappear. Instead of going to the country on the weekends we simply stayed home. My heart was broken because I never saw Old Joe again. I was never told about the financial situations. I was told that Old Joe had a new rider. Having no closure with Old Joe and time to say goodbye brought pain that set deep into my heart and my being.

The crowning blow came when my brother said to me in front of both my parents, "I am better than you, because I am the natural child in this family, I am better than you." He was never corrected and I was not made to feel part of the family by either parent. I cried from deep within and the slow, unsettling feeling began to create uneasiness in my spirit. "It came on each time we were all together, especially when Oliver was walking along side or sitting next to my mother and father." That feeling of not belonging, although indescribable and unidentifiable at that young age, was real to me. I no longer had my horse to ride and that sense of oneness with my horse and the feeling of belonging was disappearing. I felt like an orphan.

How does one define an orphan? Is it a foal roaming alone, searching for water on the open plains? Is it a dog discarded from its human family, placed in a pound, waiting for either a loving home or euthanasia? Maybe it is the redheaded stepchild with purple freckles and no front teeth. Or is it simply abandonment, that unwelcome feeling that settles deep in your soul and burns into your heart? Look into the eyes of dogs at the pound and you can see abandonment. Look into the eyes of children whose parents resent and neglect them. Regardless of circumstances, whether human or animal, abandonment is real and it is painful.

The feeling of abandonment was worse for me at nighttime. I remember going to the bedside of my father and mother, crying and wanting to be held. I needed to know I was wanted. My parents would tell me to go back to bed and go to sleep. Quietly I would lie down at the foot of their bed and fall asleep on the floor. I just

wanted to know and feel that I was loved. That is all I wanted. It is one thing to hear the words "I love you" but it is quite another to experience unconditional love. Unconditional love—not rejection— was what I needed. Silent waves of loneliness began to be a part of me and set me on a journey seeking answers to fill that hole within. What I needed was a loving family who saw me as their own, not as the orphan child or adopted sister.

Fortunately, the color of my eyes and hair were the same as my adoptive parents. Our overall general appearance blended together beautifully, but that is where the similarities stopped. Eventually, I was pushed further aside and began a life of struggle and heartache. This difficult journey would cause me to take my aches and pains in life and use them as stepping-stones to replace a negative foundation with one that is positive. Although I was young, I knew that I did not want to treat others the way I was treated.

I was about nine years old when I first watched the movie *Blossoms in the Dust,* the true story of Edna Gladney. I sat on the floor in front of the TV, watching the story about the lady my mother spoke of quite often. After seeing this movie several times, I began to realize how Mrs. Gladney took the heartaches in her life and turned them around for good. She made a difference in her home, her community, and in the lives of all the orphans born in the state of Texas.

Edna Gladney herself had been born out of wedlock on her grandparent's farm in Wisconsin in 1886. Her mother was barely seventeen years of age, and the birth father's name was unknown even to Edna's grandparents and family members. She diligently worked with the Texas Legislature in 1936 to have the word "illegitimate" kept off the birth certificates of adopted and abandoned children. Due to her efforts, a bill was passed in 1951 that recognized and gave adopted children the same inheritance rights as biological children. This bill also stated that adopted children should be legally adopted

instead of being placed in a home under the title "long term guardianship."

Mrs. Gladney died seven years after she handed me over to my adopted parents, but her legacy lives on through the thousands of children for whom she spent her life crusading, proving that one person can make a difference. Her efforts certainly made a difference in my life.

Life at its best is tough, but in the difficult times there is usually someone you can turn to for help. It may not be a relative. It may not be a person of the same color or economic background as you, but there is always someone who cares. The person who consistently loved and cared about me the most was my mother's mother. Because of the losses in her own life, my grandmother was able to relate and understand me. She valued me as if I was her own flesh and blood, her own granddaughter, and not an adopted part of the family. She was my best advocate, my champion who loved me unconditionally. I enjoyed spending weekends at her home as she taught me how to cook and drink coffee. What a wonderful role model for me, as she began each morning with a hot cup of black, chicory coffee, Bible reading, and prayer. She would often sit by me and read the Psalms and tell me about Jesus. She prayed for me daily, asking the Lord to protect me and guide me in the way of His righteousness. My grandmother cherished me and loved me dearly.

Born on a plantation in Louisiana in 1892, Grandmother grew up without her birth mother because her mother died after childbirth. My grandmother was the last child to be born in a family of five other children. It was now up to her father and siblings to feed and take care of her. Life on the plantation during the horse and buggy era consisted of working long, hard days. The entire family worked together picking cotton, pulling weeds, hauling water, and feeding livestock. Although my grandmother was the youngest, she, too, was in the fields during planting and harvest time. Each family member had to pull his own weight in order to have food on the table. A

fourteen-hour day was a luxury and the next day's work started all over again bright and early with another sunrise. During the winter months, when harvest time was over, grandmother received an education in a one-room schoolhouse. Her two youngest brothers would walk her to school as they were in the same schoolhouse working on their own grade level material.

When looking back on life, each of us can identify events that caused a major change. Change is one thing in life that is consistent, and changes will come. When my grandmother's father remarried, life again changed for everyone in that family. The new wife brought her own child with her, thus setting up a different family structure and upsetting the position of authority. Resentment became a part of the atmosphere, as the new wife begrudged raising a child of the deceased wife and caring for the other children. Ongoing conflict within this environment caused my grandmother, at the age of ten, to move in with an older sister, who unselfishly raised her as one of her own. Love, loyalty, and the value within that family provided grandmother with a firm foundation for the rest of her life.

My grandmother married young as many did in the early 1900s. After only ten years of marriage, her husband died in an accident. She was three months pregnant with her second child, the same child that would some day raise me. Now my grandmother had to take on the full responsibility of rearing a nine-year old child, preparing for the birth of a second child, and finding a job to support her family.

Life can change quickly and it may seem that the storms of life come hard and fast. Grandmother courageously met her hardships straight on. She seldom spoke of her family and the problems dealt to her at such a young age. She chose to stay positive. Ideally, her financial problems could have easily been relieved as her deceased husband was from a prominent plantation family of great wealth and political means. Her husband's family grew thousands of acres of cotton, owned a steam liner and a railroad for shipping their goods, and enjoyed a private train car for their personal travel. Trips were made

throughout the United States and frequently to Washington D.C. to visit the 22nd President of the United States, Grover Cleveland. However, with all this, the only thing her in-laws did was allow her to live in one of their boarding houses and have a job as a cook. Grandmother lived and worked there until the birth of her second child.

Many unanswered questions puzzled my mind as I thought of my grandmother's young adult life. Why did a family of unmeasured wealth not care about their grandchildren and daughter-in-law? Did they think the woman their son chose for marriage was not good enough for their family? They could have provided her with anything she needed. To this day, I wonder why. Why didn't they help her? I wonder if they were with her when her second child was born. Did they hold the new baby who carried on the family name? Did they help with medical expenses?

Love of money, lack of concern for others, and being consumed with self-interests are negative traits that can be read about throughout history. As I learned about my grandmother's life and how she dealt with it, I began to realize that the important things in life involve helping others. How great a feeling to be able to help a neighbor, a friend, a stranger, or an animal. Just think how far even one act of kindness spreads. Think about the peace and self-satisfaction that would come to each of us if we extended a helping hand across this nation.

My grandmother remarried a fine man and her new husband became a wonderful father for her two daughters. My grandfather lost his first wife due to a serious illness and he was raising his three-year-old daughter by himself. So these two families came together as one and both parents faithfully provided love and support for each other. My grandfather was not a wealthy man, but a man of great character and knowledge. His honesty, self-reliance, integrity, and commitment to God and family spoke for itself. He took an active interest in civic affairs, as he was a lay member in his church, a committee member

for the Boy Scout Council and a Rotary Club member. Besides being a part of his community, my grandfather was employed by the United States Forest Service and was in charge of the timber stand improvement and management programs for the states of Georgia, Alabama, North Carolina, Louisiana, and Tennessee. My grandfather also served as a timber appraiser-estimator in Texas. Toward the end of his career he was transferred to a position as a district forester in Louisiana.

How I wish I could have met him and called him grandpa, but he died of a heart attack at his home the Christmas before I was born. His love, support, and knowledge about dealing with the storms of life would have been helpful to me. He would have understood me and called me his grandchild.

My grandparents were from a simpler time when people sat on the front porch and watched the sun go down. It was a time when people talked, listened, and prayed together. Laughter was part of the evening when they sat around the table listening to the classic comedy of *Fibber McGee and Molly* on the radio. Integrity, self-worth, and a strong work ethic were as important as a good education. Values such as these were passed to me by my grandmother and continue to strengthen me year after year. Grandmother, the one who understood me better than anyone, demonstrated to me the importance of faith, family, and friends.

One of my treasured gifts from her is a note telling me how proud she is to be my grandmother. That handwritten note of love remains in a special place in my Bible. That place is Psalms, my grandmother's favorite book.

My grandmother was fortunate enough to live with my parents when she could no longer care for herself. After 104 years, she was too tired to continue and looked forward to being reunited with her family in her heavenly home. It was a blessing for me to be with her during her last days on earth, holding her hand as she took her last

breath. Part of me went away with her that day, but she left wonderful memories for me to enjoy. Even though her days were simple, many times she expressed to me, "Life is a journey."

Words can be powerful in any context. They can bring life and healing, or they can bring death and sorrow. Unlike my grandmother's gentleness and kindness, the rest of the family was tough and hardhearted. Throughout my childhood, my family consistently called me dumb, stupid, and ugly. They seemed to enjoy mocking and making fun of me in front of others.

Looking back on my school years, I remember that much of my early education was easy and fun. Schoolwork was presented in a way that I could understand. My elementary years started out in a private Christian church school. The class size was small with one-on-one teaching at times. This was helpful to me as I was working at my own pace and was provided with a variety of learning techniques and encouragement.

In the third grade, I was transferred into a public school closer to my house. The learning environment was much larger and the pace was faster. As the reading level increased, I was slowly being left behind. I began to sink inside just like I was being pulled down by quicksand. The harder I tried to climb out, the more I sank. My inward determination to succeed was covered over by my family's embarrassment. My brother had no difficulties in school and he enjoyed reading and doing his schoolwork. My sister was in college making excellent grades while participating in a variety of sorority activities. My inability to excel in school brought my family shame and disappointment. My parents shunned me in public and my siblings acted like they did not know me. My grandmother was the only one who said she was proud of me.

With sadness, I recall eating out with a good friend and her family. Mother asked my friend, "What did you make on your math test today?"

My friend proudly replied, "I made 100." Mother loudly exclaimed for all to hear, "Really! Terry made a zero! She can't read and she is not very smart. I just don't know why she can't learn."

Teaching styles during the early 1960s focused on addressing auditory learners. All students were taught the same way, and individual learning styles were not taken into consideration. Students were expected to enter the room quietly, sit at assigned desks neatly arranged in rows, and be ready for instructions from the teacher. If a student disrupted class, he or she had to stand by the blackboard for a period of thirty minutes and write, "I will behave," over and over until the board was filled with handwriting. Also, a wooden paddle on the teacher's desk was always within reach in case it was needed to reinforce the writing exercise.

I was not a behavior problem so I was not scared of the paddle. But I was scared, actually terrified, to be called on to read out loud in front of my classmates and teacher. Learning was a challenge because I could not read fast enough to keep up and no one seemed to know how to help me. The pace was set for the smarter and brighter students. It was those students who called me dumb and stupid. It was those students who went out for recess while I stayed in the classroom and worked.

I worked with tutors on Saturdays who would read to me and have me read the same sentence back to them. Simply repeating words was not teaching me the basics of reading. It didn't seem to matter how hard I tried, by the end of the fourth grade I had a history of making poor grades.

My academic reputation preceded me as I entered the 5th grade. Dr. Kemp, a school official, devised a plan—a plan for his personal gain in order to promote his career. His plan involved studying the effects of behavior of children who were removed from their home environment and placed in a foster home setting. Removing the child from their home was Dr. Kemp's sure-fire cure for reading problems

and he convinced my parents to withdraw me from my local school and send me away to another school.

How ironic that the same parents who chose me would turn around and send me far away within a few days of Dr. Kemp's recommendation. The day after Christmas, I was told by my mother, "You are failing the 5th grade and your school administrator wants us to send you to another school and another home." I remember as if it were yesterday, as I recall my placement in a foster home at the age of nine, the spring semester of my 5th grade school year. Because of failing grades, my parents released me into the hands of complete strangers with the hopes of keeping their reputation from being tainted by the failing of a child in their family. So by the end of December 1963, on a cold Sunday afternoon, I found myself in a foster home with a new family of three natural children and two other foster children.

I have little recollection of the drive to the foster home and no idea of the exact direction of travel. Before getting into the car with my parents, my grandmother was so hurt over this decision that she could not even say goodbye to me. My dog, Topper, seemed to know something was wrong also. I remember that I sat in the back seat with my head down, staring at the floor and scared to death because no one really told me what was happening. After the long drive, my lone suitcase and I were dropped off with this strange family. Thirty minutes later, my mother and father drove away, leaving me with unanswered, frightening questions about my future.

Chapter 2

An Invisible Thread

I HAD NO IDEA HOW MANY changes awaited when I walked into that old farmhouse. My bedroom at my parent's home was spacious and I didn't have to share it with anyone. What a surprise when I learned that my new room was a converted living area with three twin beds for the foster children. My bed was against the window, and two sisters placed there by Child Protective Services had their twin beds on the other side of the room. At both ends of the room, curtains made from sheets served as the doors. The clothes closet was simply a wooden pole attached diagonally to one corner of the room.

What a cultural shock for me. I went from my small family to a family of eight in a one bathroom house. Taking in foster children provided income for this poor family. Since Child Protective Services did not place me in the foster home, my parents sent a check on a monthly basis to cover the cost of my room and board. Mr. Hamilton, the father in the foster home, worked a midnight shift driving heavy equipment in a lignite mine. He would come home early in the morning after all the kids rode the bus to school. When we arrived back at the farmhouse in the late afternoon, Mr. Hamilton had returned to his night job.

We took shifts eating, sharing household chores, and waiting in line for our turn to take a bath. The children took turns saying grace at the table, thanking the good Lord for the blessings of the day. Mrs. Hamilton and the children attended the local Baptist church every Sunday morning. The homesteaders in the community built this church over a hundred years before. Mr. Hamilton didn't go with us

because he was working. Our schedules stayed the same each day; we were asleep by 8:30 p.m. and were up and at 'em the next morning at 6:00 a.m.

Thinking of Sunday mornings spent in that little country church always makes me smile. The old hymns were sung at the beginning and end of the service just like they were when I would go to church with my grandmother. The congregation would take time at the end of each service to pray for the needs within the church and the community. Although not called by name, the children in the Hamilton's foster home were prayed for weekly. The older church members were nice and kind to me but the children who were my age shied away and would just stare at me. They were the same children I would see at school the next day.

Kindness to a child can create internal hope and build a pathway to success. One simple message at church set deep inside my being and was recorded in my spirit. It gave me an invisible thread to hang on to. From my heart, I wrote this prayer:

Lord, I want to be what You want me to be...
I want You to be proud of me...
Lord, help me walk through the valley so low to the top of the highest hill.
Lord, I want to travel the journey You set before me.
Please hold my hand and help me to live in the center of Your will.
I need You, Lord, and I want You to be proud of me.

Bedtime was a favorite part of my day. This quiet time gave me a chance to think and to pray as I wondered what was going to happen to me. In my mind, I could hear my grandmother praying for me. She taught me to pray daily for God's guidance and protection. I also prayed that God would help me to learn and make good grades. Each night as I prayed, I would listen for the train to pass by on the tracks across the highway. Sometimes, when the weather was clear and the wind was blowing just right, I could hear the coyotes howl. I would lie

in bed and try to imagine what the coyotes were saying as they howled to one another.

During the day, hobos riding the rail in the boxcars would get off when the train stopped. They would walk across the highway to the old green farmhouse that was easy to see from the railroad crossing. I guess the hobos knew unselfish people lived there and would share their food to help another in need. Mrs. Hamilton was a compassionate and kind woman. She would leave water or buttermilk in a mason jar and a sandwich wrapped in foil on the front porch for those homeless wanderers so they could have something to eat that day. Life lessons unfolded for me as I watched, listened, and learned. Sometimes I would politely speak to one of the homeless men, but never carried on a conversation. Glancing into their eyes, I could see gratitude for a bite of food or a drink of water. Hard times etched the faces of these men as they rode up and down the tracks trying to find work, hoping to make another dollar to buy some food. Watching scenes such as these taught me that the simplest act of kindness could have an impact on someone's life. Words from my grandmother would float through my mind and I would recall that she always told me it is better to give than to receive. Watching Mrs. Hamilton's generosity helped me realize that giving has a greater internal reward than taking or receiving.

I also learned in Sunday school that no person is better than another and that God loves us all unconditionally. Stories learned at church, and watching Mrs. Hamilton share meals with strangers, helped set the stage for me to begin to give and to help others when I could. Many times, all I had to give was a smile or a kind word, but I knew that even those small acts could be a source of encouragement for someone. Years after these childhood memories, I am able to share with friends as well as strangers when I see someone in need of a helping hand.

Some of the more pleasant times I had at this foster home happened on weekends. On Saturdays, Mr. Hamilton was not at work and spent

time tending to chores on the farm. He was kind enough to let me ride in his old 1950 Ford pickup truck as we went to feed the cows. He taught me the timing of the shifting of gears in the floorboard stick shift truck as we drove up and down the hills and over the creeks. Sometimes the entire family went and helped with chores and sometimes it was just me. I enjoyed being in the country, feeding the livestock, and watching for wildlife. During those brief hours on Saturday, I was almost able to forget that I was in a foster home with strangers, that I had no idea what was going to happen to me, and that I had a big empty spot inside. For just a little while, the freshness and beauty of God's creation provided me with some internal peace.

God heard my prayers as I silently cried out to him each night. I was lonely. I missed my grandmother. I missed my dog, Topper. I missed my home and my friends. Why was I here? Would I stay with this family or would I be sent away again? So many unanswered questions were on my mind.

I would receive letters from my mother and grandmother telling me how much they loved and missed me. I never received a letter or phone call from my father. On occasion I would get a phone call from Lindsey as she was attending college fifty miles away from my foster home. About once every six weeks, she would come pick me up and take me with her to spend the weekend with the family. On her way back to college, Lindsey would drop me off at the foster home. If she had friends riding home she would not contact me. My sister did not want her friends to know I was in a foster home.

On occasion when I got to go back home, I would go visit my friend Karen. Although she was one year older, we attended the same school and she knew what I was going through. Her Uncle Luke lived down the street from my parents and would often invite me to go horseback riding with his entire family. Karen was like a sister to me and we would talk about our problems together. When Karen found out I was sent away for failing in school she told her Uncle Luke what was happening to me. He was speechless and could not believe what

he was hearing. He told Karen, "I know what Terry needs to help her get through this tough time. She needs something to love and care for."

Chapter 3

Compassion and Caution

SIX WEEKS AFTER ARRIVING at the foster home, Karen's Uncle Luke drove up in his Ford truck hauling a two-horse trailer. I was outside by the barn when I saw Mr. Luke. I was surprised and wondered why he was there and why he was pulling a trailer with his truck. He stopped by the barn and I stood in silence as I watched him unload one of his horses. Mr. Luke took great pride in his horses. All of them could be traced back to the foundation horses that made history in the American Quarter Horse Industry.

I ran to Mr. Luke and gave him a big hug and said, "I am so glad to see you!"

Mr. Luke looked down at me and said, "Terry, I am leaving King here with you."

Excitement, appreciation, and joy flowed through me when I realized that he was leaving King for me to ride and care for. This solid foundation bred Quarter Horse, a son of the 234th horse to be registered in the American Quarter Horse Association, was bigger and taller than life.

Together, Mr. Luke and I walked King to his stall. After the stall door was closed, fighting back my tears, I looked up at Mr. Luke and said, "Thank you. I promise to take good care of King. Thank you, Mr. Luke."

Mr. Luke's answer was, "King will help take care of you." Tears dripped down my face as Mr. Luke walked back to his truck to drive home.

This tall, dark, bay gelding became my all, my best friend, and the help I needed to get through that difficult time. I loved King and I told him every day how much he meant to me. At every opportunity possible, I jumped on him bareback and rode to the top of the hill. There at the top, King and I could conquer the world. We enjoyed every mile of the ride. Knowing that no one was around to hear me, I would belt out my prayer while sitting on King at the top of the hill:

Lord, I want to be what You want me to be...
I want You to be proud of me...
Lord, help me walk through the valley so low to the top of the highest hill.
Lord, I want to travel the journey You set before me.
Please hold my hand and help me to live in the center of Your will.
I need You, Lord, and I want You to be proud of me.

What an act of compassion from Mr. Luke. It seems he felt my struggle, picked up some of my burdens, and helped carry them the best he could. I know God honored Mr. Luke for his tremendous gift of friendship. Gratitude grew in every part of my being each time I rode King and thought about my unselfish friend, Mr. Luke.

To this day, I am grateful that he and his family cared, and treated me as one of their own. Sometimes, all it takes is a listening ear and a friendly smile. Mr. Luke's act of kindness and his way of carrying my burden would forever change my life and the way I felt about people and how I treated others. I am proof that one act of kindness can change another person's life. Mr. Luke changed my life because of the friendship he showed to a lonely child who was crumbling and suffering inside.

Having King to ride and be with made my days at school so much easier. I could not wait for the last class period to be over so I could

go back to the foster home and get my homework and chores done. After the chores and before the dinner hour, I spent time with King. I brushed and brushed him, cleaned out his feet, and told him how much I loved him. The next day after school could not come around quick enough for me.

One day after I got home from school I discovered that the other two foster girls were gone. They rode the bus to school that morning but they did not ride the bus home. I wondered where they were, as we always rode the bus together. Their beds were made up with fresh sheets and their clothes were no longer hanging in the makeshift closet. Their names were never again mentioned and I had no idea where they were or if something had happened to them. No one said a word and I was worried about what might happen to me. Would I disappear, too? Would I be removed from the home and placed somewhere else? Would I become someone whose name was never uttered again?

As these unanswered questions created an internal fear, one thought was clear to me. No matter what happened, I was not going to leave my friend King behind, nor was I going to let anything happen to him.

The absence of the two sisters brought additional solitude and loneliness. Now there was no one to play games with and no one to talk with at night as I slept in the room by myself. Many times there were no adults in the house. This exposed another looming problem for me to deal with... the dirty old grandfather who quietly appeared from time to time. Now there was no one to help me feel protected from him.

Since my first day of arrival at the foster home, I was leery of the so-called "grandfather." This wretched man lived in the house next door with the parents of Mrs. Hamilton. He would frequently amble back and forth between the two houses to visit or eat a meal. With the

disappearance of my two roommates, I felt more vulnerable. At that point, I knew I had to be wise about being in that house alone.

Animals have a natural sense concerning danger. Many times I had seen King react to a loud noise, a quick movement of a deer, or the sudden appearance of a rattlesnake. Deep in my gut was that kind of intuition. To deal with my snake, I began keeping a sharp pocketknife in my back pocket. I was constantly aware of my environment and I kept my guard up because I never knew when the old man would appear.

One day it was cold and windy. I was alone in the house and did not hear the opening of the door. Suddenly, he called my name and demanded that I come to the front room where he was standing. My heart was pounding with fear. I ignored him, but reluctantly went there after he yelled at me to come to him. As I approached, he reached out and grabbed me and roughly pulled me to his face.

With a sharp tone in his voice, he said, "Terry, don't you ever let anyone do *this* to you!"

Then that nasty old man put his lips on mine. At the same time, his hands began to roam over my nine-year-old body.

With every bit of energy I had, I pushed him away, turned and ran as fast as I could out the front door. Clearing the porch and steps with one jump, I cried out "Help me, Jesus!"

The old man went out on the porch and kept calling my name. I was hiding in the open garage in the back of the house. Holding my sharp knife in my hand, I was ready to use it if I had to. After what seemed like hours, Mr. and Mrs. Hamilton and their family finally drove down the driveway and into the garage, which allowed me to safely return to the house. I was scared to tell anyone what had happened and how the old man had acted. Who would believe me, anyway! I was just an orphan kid living in that house. It never occurred to me to

tell because I was taught that adults were always right, no matter what. I knew for sure my parents would not believe me.

The close call with the old "grandfather" changed my fragile sense of security. Even though I was only nine years old, I had a strong sense of right and wrong and I knew he was dead wrong.

From that day on, I kept my knife in my pocket. I was not going to fall into his trap that was a snare of indecency and exposure. To the best of my ability, I was not going to let him or anyone else take advantage of me. My goal was to keep my mouth shut, mind my manners, and remain respectful until the day I hopefully could leave that place.

Finally, my 5th grade school year was drawing to a close. I received my report card and I had passed all my subjects. Overall, I had a C average. The teachers made comments such as, "Terry adjusted very well to her new school." "Terry is promoted to the 6th grade." I may have passed the 5th grade but I still struggled with reading and the process of learning. Nevertheless, because I passed, I was able to go home—back to where I came from, anyway.

Memories of being taken to the foster home are vague because I was so scared and had no idea what was happening. Leaving there, however, left lasting memories within. I saw it as going from the place where I was the foster child back to the home where I was the orphan.

Chapter 4

Gratitude for Friends

MY PARENTS ARRIVED about ten in the morning on the first Saturday after school was out. Their drive took a little longer as they were pulling Mr. Luke's horse trailer so King and I could go home together. Early that morning I got up, brushed King, and was ready for the drive back to his barn, his family, and the horses he was raised with. His feed sat next to my suitcase that was placed on the front porch of the farmhouse. King and I waited together for a station wagon and trailer to turn into the driveway. When I saw my parents coming, I patted King and told him, "You're going home, big boy. Thank you for loving me."

Mr. and Mrs. Hamilton walked with King and me to the car. The old "grandfather" walked behind them with a constant stare in my direction. I said goodbye to Mr. and Mrs. Hamilton and thanked them for being nice to me. After King was loaded in the trailer, I was forced to say thank you to the nasty old "grandfather" for taking care of me. I guess that was the polite thing to say whether I meant it or not. That was the beginning of choosing my words wisely and not saying things I didn't mean.

The encounter with the old man was never spoken of and neither was the foster home. It remained a silent subject buried under the façade of normalcy. In fact, sending me away to a foster home was never mentioned for fifty long years. As far as my parents were concerned, it was as if it had never happened. However, one week before my mother passed away, she brought up the fact that I did not trust her. This discussion with my mother was unexpected since she was more

interested in being with her friends and playing golf and bridge than talking with me. Mother-daughter discussions never occurred in my house. Her ability to hone in on emotions was almost nonexistent.

I remember sitting at the table with my eighty-seven-year-old mother, reviewing her paper work and paying bills for her. On a monthly basis, I personally took care of her financial needs because her eyesight was deteriorating. Mother could no longer read large print material or write legibly, because of the wet form of age related macular degeneration that slowly disintegrated her retinas and distorted her vision.

We sat there and talked, which was rare. All of my life I had been told how I felt and what to do. But this time was different as she said to me, "You are always grateful, but you don't trust me and I don't understand why."

I tried to tell her why but she continued to talk and talk. I finally said, "If you would like to know why I don't trust you, I will tell you if you care to listen." It took a while for her to listen, but she finally did.

My talk with mother went like this, "I remember sitting at the kitchen table trying to complete some math problems that were given to me by my 5th grade teacher. These problems were a review for an exam that we were going to have at the end of the fall semester. My classmates completed their review work during school time but I was not able to finish my work, so I brought the math problems home with me. I was struggling to read, struggling to learn, and I needed extra help. You were in the kitchen preparing dinner when I asked you for help. You walked over to the table and sat down next to me. I slowly read the word problems out loud to you. With all my might, I was simply trying to understand what I was reading. Instead of listening, you gave me the answers without any explanation. Do you remember what happened next? You became angry with me because I was having trouble reading."

There was silence from my mother. I then said, "Do you remember slapping me in the face and calling me stupid? Do you remember seeing the tears run down my face? Mother, two weeks later, I was sent to a foster home with no assurance of my return. I was nine years old!"

I continued to explain to my mother, "I know I was an embarrassment to you and the rest of the family by making poor grades. But through it all, I had a burning desire to learn and to make good grades. I just needed guidance on how to sound out words and to process the sentences set before me. What you and the teachers really didn't understand is a term called dyslexia."

It may seem odd in the 21st century, but when I was a child in the 1960s, dyslexia was not well known. Today, educators understand that dyslexia is a specific disability that can affect reading, spelling, writing, and math. No one knew that about me. It took practice, patience, and courage but years later, I taught myself how to read, study, and retain what I was reading.

For once in her life, my mother asked me to forgive her. In a sorrowful voice, she said, "I made a horrible mistake in sending you away and in following Dr. Kemp's advice."

I replied back, "I forgave you years ago."

Forgiving can be difficult, but the hardest part is to push through the pain of hurt and mistreatment. I had to diligently work through years of cruelly being called stupid, being shamed and told that I couldn't learn. Many times when I was being made fun of at home, I wanted to say, "Is a stupid child a ruin to the family or is it the family's responsibility to teach and train a child not to be stupid?"

Yes, forgiveness is an ongoing process, and many times has to be applied over and over. Forgiveness is the gift we give to ourselves.

Mother was scheduled for surgery the following week for the removal of a cancerous tumor in her lungs. She had already courageously fought one battle with esophageal cancer. A few years before, Mother survived the aftermath of surgery, chemotherapy, and radiation treatment for her esophageal cancer. Watching her go through cancer treatment again made me more mindful of my own health.

There are many things I am thankful for. One of the more important things is that God allowed me to have that discussion with Mother before she went in for her final surgery. The operation was a success, but complications set in and her health quickly deteriorated. Lifelong friends came to say their goodbyes. Mother would reach out and touch them, and would recognize them by their voice, as her eyesight had completely failed.

Her friend Miss Lili, who was precious to me, stood over my mother and said, "Goodbye, my dear friend; I will see you in heaven."

Mother loved her friends and would say, "Friends are made when you are young and are treasured as you get older." She and her friends had years of memories with one another.

The following Sunday, mother had her glorious homecoming as she went to her heavenly home where she found loved ones waiting for her. I would like to believe that her mother, the father who raised her, and the father she never met were first in line to greet her.

After Mother's funeral, I remained at the gravesite while the casket was being lowered into its final resting place next to my beloved grandmother. During this time, I reflected on the conversation I wished Mother and I could have had. I wanted to thank her for adopting me and giving me a home. I wanted so much to share with Mother how God put circumstances in my life to create a heart that yearned to follow His will. There would have been a long discussion on how my desire to please God gave me the strength to endure hardships and the determination to conquer what might seem impossible.

It would have been so satisfying to say, "Mother, let's have a cup of coffee and spend some quality time together talking about God's influence in my life." I would have admitted that, "Yes, I am a simple person. A simple person, however, can be extraordinary if they have the drive to succeed and the courage to press through the mud of life."

Reminiscing, I would have explained how my grandmother and family friends wrapped me in their love so I would feel secure, and how grandmother prayed over me daily and told me about the 23rd Psalms. Mother and I would have talked about her friend, Lili, and how she became a source of encouragement to me after I returned from the foster home. Miss Lili loved me just like a daughter and her friendship helped to change my life. I wish I could have expressed to Mother my deep gratitude for Miss Lili's friendship, which was a free gift that helped me to build internal strength, hope, and courage. I learned from Miss Lili to pass the gift of friendship and kindness on to others. I learned this same lesson from Mr. Luke and his family. Acts of kindness from these adults might have seemed like small things, but in my life, they were enormous and life-changing.

Many hours could also be spent talking about another family friend, Mrs. Smith, and how she taught me math, beginning with the simple basics and progressing through to college algebra. Her teaching set me on a pathway for learning. She was a natural teacher who showed me the value of a good education and helped me to experience the thrill of success. Mrs. Smith believed in me.

If Mother and I could have had the talk I wanted, she would hear me speak of the greatness of Jesus Christ, how He restored my life, and how He has blessed me beyond any imagination. Jesus restored the part inside of me that was tattered and torn by harshness. Today, I am no longer broken. I am whole. I am moving forward in the peace and glory that God gives.

After the last shovel of dirt was scooped over Mother's grave, I placed a red rose on top of the soil, and said, "Mother, I wish we could have been friends." As I walked away, my mind continued to move backward in time as I thought about the life-changing events that made me a stronger person. My long drive home was filled with thoughts of the past and gratitude for the friends that God sent me.

Life-changing events have the ability to throw you flat off course or to make you stand up taller. Life in a foster home was definitely a challenge but I suppose being sent there accomplished a few things. First of all, I passed to the next grade. Second, my parents and siblings were spared the embarrassment of having me fail the 5th grade. Third, Dr. Kemp was able to collect more data for his personal research project on adolescent behavior. It was Dr. Kemp who made the arrangements for my parents to withdraw me from my home school and relocate me to a foster home. I was never informed of any data collected on my behavior or the results of my behavior in an adopted home versus a foster home. I was never told how being sent to a foster home would make me smarter. What Dr. Kemp, in his all wisdom, did not focus on was my reading disability, the problem for my struggles in school.

After coming home from the foster home in June, I spent weekends, holidays, and summer time riding horses with Mr. Luke and his family. Being with them and learning about horses were some of the happier times of my childhood. Mr. Luke taught his niece, Karen, and me how to saddle and unsaddle the horse in a proper and safe manner. We were taught how to use the reins so that we were gentle with the horse's mouth. When the horses were unsaddled, Karen and I would clean the horses' feet before turning them loose in the pasture.

Karen and I learned how to clean and oil saddles and bridles. Bridles and halters were hung on a nail under each horse's name. After our horseback ride, Karen and I made sure that all twenty bridles were

clean and hung in the correct spot. King's bridle and halter hung in the number one spot in the tack room.

The Luke family was more family to me than the family that raised me. They treated me like their own, not a foster child and not an orphan. Their kindness kindled love in my heart and changed my life. Many weekends we would stay overnight at the ranch in a small two room camp house. One room was filled with bunk beds and the other with tables and a small kitchen. As a family, we would ride horses during the day until early evening time. As the sun went down and night was settling in, we would sit around a campfire, roast marshmallows, drink hot chocolate, and sing songs. Some Saturday evenings, if the moon was full, Mr. Luke would hitch the wagon to the tractor and take us on a hayride.

On Sundays, we were eager to go to a small country church where everyone knew everyone. Invariably someone would say, "Here comes Mr. Luke and his gang." After a meal outside on the church grounds, we would head back to the ranch. To help contribute something, I would clean saddles, muck out stalls, and help feed the horses. Although I was ten years old, it was important to me that they know how much I appreciated them treating me like family.

Even though Mr. Luke passed many years ago, his acts of kindness will live in my heart forever. Mr. Luke and his family lived a life according to the word of God. I shed more tears when he died than I did for the father who raised me. I am thankful that Mr. Luke taught me so much about horses and how to train and care for them.

My love for horses grew with each year I rode with Mr. Luke. But deep inside, I had a burning desire to have my own horse to love and care for. For two years, I begged my father. During that time, I did extra chores at home, saving my money to buy my own horse. I would mow the yard, rake leaves, and clean out the swimming pool. My father would agree that I could buy a horse and then he would change his mind. He proved to me over and over that he was not trustworthy, and that he did not keep his word.

Terry, age 11, riding King.

Finally, when I was about twelve years old, the day came when my father consented to my buying a horse. He took me to a place where horses were going to be put up for auction. As I looked at the horses in the holding pen, a young two-year-old filly walked away from the herd and came directly toward me. Her ears were alert, her eyes nice and round. I stood watching her until she stopped. Looking directly into her big beautiful brown eyes, I saw no sign of fear, just curiosity and kindness.

This young filly had kind eyes, which are a sign of an even-tempered horse. The expression in a horse's eye will tell you how they have been treated and how they interpret their world. Her full blaze face, four white stocking feet, and black mane and tail set off her dull coat. Even though she was thin and uncared for, I wanted this filly for my own, and I thought she was beautiful.

Soon I located a pasture within walking distance, about five miles from my house, and that location became the new home for my young filly, Baby Doll. Time, love, kindness, and special care quickly paid off as my horse developed a sleek, shiny black coat and became more beautiful than ever. I loved that horse and she and I had many fun times together riding through the pasture. Riding bareback, we would trot barrels and in my mind I imagined that we had won first place. It did not matter to me that my barrels were an empty feed bucket. I told Baby Doll she was the prettiest horse in the world, and that I was the best rider in the rodeo.

Baby Doll was my best friend. She always listened to me and seemed to understand. Every day we spent time together, riding in the pasture, eating apples, and enjoying each other's love. For the next two years, I continued to work hard doing chores and babysitting so I could pay the pasture rent, farrier fee, and feed bills for my horse. I was proud to earn money and have the responsibility of owning her.

Wintertime brought additional chores, as Baby Doll would need warm water in her stall. I couldn't afford a water hose, so daily I hauled water in a five-gallon bucket from the trough to her stall. The water was heavy and it was physically hard on my back but I wanted my horse to have water in her stall during the cold winter nights. One cold, rainy, winter day, a neighbor who watched me struggle to haul water kindly gave me a hose and a water trough to set up and use in the barn area. It was that same winter day that my world came to an end. While I was rolling the metal water trough down the lane from the neighbor's house to the horse barn, the movement of the trough spooked Baby Doll. Frightened, she ran, tried to jump the fence, and

immediately became tangled in the deadly barbed wire. The wire completely tore her shoulder muscles away from the bone. In a full panic, I ran to her as fast as I could and saw blood gushing on the ground as she stood wrapped in wire. The pain I saw in her face matched the pain that was in my heart. That day, Baby Doll and I shared something new together...tears of sorrow.

The veterinarian was called and Baby Doll was taken away to the vet hospital.

Being too young to drive, I had to rely on someone to take me to see my horse. Two days after the accident, my parents finally took me to the clinic to see Baby Doll. When I opened the door to her stall, I called her name, and she started nickering her heartfelt reply. I'll never forget the way she looked at me as she stood there with an untreated, lacerated shoulder. Shame and sorrow consumed me. As a fourteen-year-old, I could do nothing, and my parents, who held the power, chose to do nothing. They would not pay for treatment for my horse nor would they pay for having her mercifully put to sleep.

My parting words to my beloved mare were, "I love you, Baby Doll. Please forgive me for scaring you." A few hours after I left the clinic, I called back to see how Baby Doll was doing. At that time, the vet said, "She's dead."

The finality of death brought pain upon pain. My father enjoyed taunting me as he said, "Your horse has been hauled off to the rendering plant and turned into barbeque." While the smirk was still on his face, my mother added her own comments. With no compassion for how I felt, mother said, "I'm glad she's dead. I'm tired of having to take you to the feed store to buy feed." My heart was broken and I felt like I was the one who was cut in half by a barbed wire fence. No one in my family ever said they were sorry about the death of my horse.

Words spoken or unspoken have the power to bring their own degree of pain. The pain in my heart was indescribable and the

situation with my horse was unspeakable. I stayed very quiet at home and at school. I made little effort to engage my family in a conversation, as they were not concerned with my hurt. On weekdays, I would come home from school, go to my room and close the door. I cried and asked God to forgive me for the mistake that I made with Baby Doll. I prayed that God would have a special place in heaven for my horse and that her bridle would be hung in the tack on a nail under her name. It took months, but finally the pain eased up, and I knew God had forgiven me. I realized that God forgave me the first time I asked, but it took my mind a long time to absorb His forgiveness and to forgive myself.

Chapter 5

Fortitude and Tenacity

THE NEXT FEW YEARS were rough and my desire to succeed in school dwindled. I continued to struggle to read and absorb what I was studying. At this point in my education, the school officials and my parents felt that I did not have the intellectual ability to attend college so they directed me to work-study programs. This pathway reduced the amount of academic courses I was required to take and provided me with more hands-on experience.

While at school, I only made a halfhearted attempt to fit in with my peers because my desire was to be with animals. Working with animals was just part of my natural born talent and strengthen who I was.

With the intent to divert my attention away from animals, my mother signed me up for cotillion lessons. I attended this affair once a week and was taught the finer points of social grace and etiquette, formal dining manners, and dancing. My mother thought this would be an outlet to help develop poise, confidence, and leadership skills. In order to fit in with the moment, I wore a garter belt with black nylon hose pulled up tightly around my legs, a long slip and a black dress that covered my knees. I had matching black patent leather shoes, which squeaked and hurt my feet. Cotillion balls, fancy lace petticoats, and tea in delicate china cups were forerunners leading up to formal debutante balls with all the proper social etiquette that went along with them.

What I needed instead of a white gown, satin gloves, and an escort wearing a white-jacketed tuxedo was a dog to befriend. In order to fulfill my passion for animals, I did chores at home and babysat for two of my neighbors. In a few months I had saved thirty dollars. While searching the classified ads, I located a mixed breed puppy for sale. Twenty-five dollars later, I was the owner of a new friend, Sassy, who helped me cope with the loss of my horse. She was a loyal dog. Sassy had lots of energy and every day we would go walking through the neighborhood. Brushing her and keeping her black and silver coat shiny brought me happiness. Knowing she was waiting for me at the end of each school day gave me something to look forward to.

Before the end of the tenth grade, students were required to pass the Presidential Fitness Test that included running the fifty-yard dash in a timely manner. On my first attempt, I ran twenty feet and fell. Coach told me to get up and try again. I fell again while I was trying to run as fast as possible. After those two falls, my back began to hurt and pain began to radiate down my right leg. The pain increased and eventually my right leg became numb.

Several days later, my mother took me to an orthopedic specialist. The doctor explained the reason for my back pain was because I had a slipped disc and a nerve that was pinched. I was given a brace to wear during the day and a body traction device to use when lying in bed. The brace became a part of my daily attire. Although it was noticeable and cumbersome, I had to wear it to relieve pressure on my spine. I wore it to school and it made sitting in metal chairs a bit of a challenge.

After school and on weekdays, around five o'clock, Sassy and I would go for a walk even though my back hurt. She and I both needed exercise and time together.

After dinner and from about eight o'clock in the evening until six o'clock the next morning, I laid in bed with fifty-pound weights pulling on a strap that was connected to my waist. The traction was a

straight pull on my spine and I had to stay in one position and that was flat on my back. I was able to watch TV and get up and walk around occasionally. In the evening, Sassy would crawl up in bed with me and I would pat her and tell her how much I loved her. We would fall asleep together.

I did not complain about my back, wearing a brace, or the confinement of traction. I just did what I needed to do. This routine of wearing a brace during the daytime and traction at night went on for about eight months. When the radiating pain in my right leg continued to increase I would hold an ice bag on the outside of my right leg to help numb the pain. One evening, my mother saw me holding an ice bag on my leg and asked if I was hurting. I looked down at the floor and said, "I'm okay." The next morning, she contacted the doctor's office and they immediately scheduled another set of x-rays.

After the X-ray procedure was completed the orthopedic specialist informed my mother and I of the results. I received devastating news. The doctor said to me, "You will never ride a horse again. You might even have to spend the rest of your life in a wheelchair."

Sitting in the chair across from the doctor, refusing to accept this "death penalty," I looked him square in the face and said, "That's just what you think!"

That remark was declared disrespectful and I was reprimanded immediately. The doctor then informed me that surgery, fusing of the lower lumbar spine, was now the only option. So right before Christmas of my junior year in high school I had a spinal fusion. The surgery took hours as the orthopedic surgeon successfully removed bone from my right hip and grafted the same bone into my lower spine.

After surgery, I spent a week in the hospital learning how to walk and dealing with pain. When I was dismissed from the hospital, I rode home in an ambulance. I thought it was strange that my father was too

busy to drive me home from the hospital. He was at work while my mother and grandmother were at home waiting for me to arrive home from the hospital. My mother's friend, Miss Lili was also waiting at the house with my mother and grandmother. Miss Lili knew I loved her homemade carrot cake with cream cheese topping so she got up early that morning to make a cake especially for me. I loved my mother's friend as much as I loved my grandmother. Miss Lili loved me also and would often remind me of the day she hung pink balloons in the trees in the front of my house as she and my grandmother awaited my arrival.

After the ambulance pulled up in my driveway, I was helped off of the stretcher and into a wheelchair. I kindly asked the driver to push me in the wheelchair to the backyard. I explained to the driver that I missed my dog and I knew she was missing me. The driver took me to the backyard by the gate so I could see Sassy, but she was nowhere to be seen. My mother walked over to me in the backyard and told me that my father had taken Sassy to a boarding kennel. My grandmother stood in the background with tears in her eyes. Miss Lili had to look away from the hurt that was on my face. They already knew what happened to my dog.

Mother informed me that Sassy chewed some shingles off the side of the house while I was in the hospital. Your father was furious and decided your dog must go live somewhere else. Before walking away, Mother said, "Your father placed a classified ad in the local paper stating free dog to a good home."

All of this happened while I was in the hospital. My grandmother and Miss Lili tried to console me but my heart was too broken.

Losing Sassy was another loss for me and was especially difficult as I processed that sadness along with other emotions. No longer would I have my Sassy to sleep with me or lay down at the foot of my bed. When people called to inquire about the ad for an unwanted dog, Father forced me to talk to them and tell them about Sassy and to

decide where my dog should go live. This was impossible for me to do because of my crying and losing my dog that I loved. Once again, I was shamed and called stupid by my father because I could not talk to the person on the phone.

My father was quite pleased when he found a ranch where Sassy could live. Then he would brag and exclaim that Sassy would be much happier there than living with me. Once again, Father's words and actions indicated the condition of his heart. They clearly showed that he was not concerned about my happiness, my love for my dog, or the dog's love for me. I never saw Sassy again. The pain in my heart was far greater than the pain in my back.

I stayed in my room and asked God to reach down and pull me up out of the valley of tears. Deep down in my heart I cried:

Lord, I want to be what You want me to be...
I want You to be proud of me...
Lord, help me walk through the valley so low to the top of the highest hill.
Lord, I want to travel the journey You set before me.
Please hold my hand and help me to live in the center of Your will.
I need You, Lord, and I want You to be proud of me.

Life goes on and so does the educational process. I was placed on homebound services with a teacher coming to my house two hours per week for the remainder of the school year. My homebound teacher would communicate with the classroom teachers about what I needed to study and any assignments I needed to complete. Every Monday, the homebound teacher would come to my house for one hour and give me assignments for the entire week. I was expected to have all my work completed by Thursday. Every Friday morning, the homebound teacher would come back for another hour and pick up my work so she could return the work to the sending teacher. The same process started over the next Monday. Most of the assignments consisted of reading chapters in my schoolbooks and answering the questions at the end of each chapter. As I read each subject material,

I wrote on a piece of paper the key facts with a list of information underneath each key event. This list became my study guide for the final that would be given to me at the end of the school semester. When it came to math, I had to start at the first chapter in the book and teach myself step by step how to solve the problems. I noticed that this was not the same math book that my classmates were using. The book assigned to me was on a much lower grade level. The work took a great deal of time to complete but through it all I was slowly learning to compensate for a reading disability. Daily, I asked God to give me the fortitude and tenacity to complete the assignments to the best of my ability.

I would sit and study by myself, at my own pace, at the kitchen table for hours during the day as I worked on my assignments. When my back got sore from sitting up I would lie down and rest. During my resting time, I would think about how I was going to live the journey of my life. I prayed for internal peace and strength. During my silent time of resting and listening to God I began to feel deep in my spirit a rising, a calling of strength, a gathering of courage. I felt a strong desire to be my best and to do my best. I imagined reaching out and holding God's hand as we walked together on a pathway of peace, hope, and love. Inside, I just knew I was going to rise above and persevere regardless of my earthly father's internal blindness, self-centered, narcissistic behavior.

Physical healing continued as I wore a back brace for the next year. The pain decreased almost on a weekly basis. Although I could not get my brace wet, I would sit on the side of the pool in my backyard and kick my feet in the water. At the age of sixteen, I finally gained freedom from the back brace and was able to begin exercising. I swam in the pool two times a day for six months in order to regain my strength so I could ride horses again. My inward determination to ride horses was not going to be stopped.

My senior year of high school went fast as I received credit for working part time and attending school a few hours a day. Miss Lili

helped me get a job in a needlepoint shop. Miss Lili herself, a master in the craft of needlepoint, visited this local shop on a weekly basis. Being friends with the owner, she made arrangements for me to have a job interview. I applied, interviewed, and got the job all in one day. I learned how to stock shelves, count inventory, wait on customers, and how to cut canvas. Once I mastered a variety of needlepoint stitches, I became an instructor for the beginning needlepoint class. I enjoyed working with my hands and meeting a variety of nice people. Working allowed me the opportunity to gain the credit I needed to graduate from high school. My back had completely healed by the time I graduated and as a result, the doctor released me to resume all physical activities.

After receiving my high school diploma I started working full time for a veterinarian. Tending to animals was my calling and my passion. It was the journey that God designed in my heart and the journey I intended to hold onto. Helping animals increased my willingness to be successful regardless of what else happened in my life. God's almost silent but powerful voice was drawing me toward the center of His will.

I enjoyed seeing all kinds of beautiful dogs, cats, and birds as I worked for a local veterinarian. What interested me the most was the interaction between pets and their owners. Some dogs were definitely the boss of the family. Cats acted aloof to their home life, and birds just squawked. Mainly what I saw was the unconditional love between the pets and their owners. This love made me long for a dog and a horse more than ever before. One day, while visiting the local chapter of the Society for the Prevention of Cruelty to Animals (SPCA), I found just what I had been looking for. He was lying in a metal cage waiting for a home, and if no one came forward soon, he would be euthanized. This one-year-old German shepherd mixed-breed dog looked at me with sad eyes, and I immediately connected with the sorrow I saw there. That day, I adopted Skipper to be mine. I took him to work with me every day, so I knew he would be safe from any trouble at home.

I worked hard to save my money and as time went on I bought my second horse, Chief. I was proud to accomplish my goal of riding horses again. Chief was a four-year-old dark bay appaloosa gelding with a solid white blanket over his hips. His black mane and tail set off his beautiful blanket. In the evenings after work, Skipper and I would go to the boarding stables to feed Chief. Almost daily, I would ride Chief and Skipper would follow along beside us. I spent many an hour exploring the ranch land that surrounded the stables.

Saturdays were especially fun as I would join some of the other horseback riders and we would ride together for hours on a ranch where the cowboy way of life was lived and respected. The ranch was a state archeological landmark in itself as the original house, barns, and rodeo arena represented the cattle business in the early 1900s. My friends and I were honored with the owner's trust for allowing us to see their ranch from horseback. We all promised to keep the gates closed so the longhorn cattle would not wander into a different pasture.

The color pattern of the cattle varied from speckled brown to solid black but the dark red and white color mixes were the most dominate color of this herd of cattle. The horns on the cattle also varied from a single twist to the beautiful curves in a double twist. The mama cows used the twist in their horns to protect their babies from predators.

On occasion the owner's daughter would visit with us and tell us more of the history of the ranch, the cattle, and the windmills. We learned that her father raised one of the nation's finest foundation herds of Texas longhorn cattle. From early sunrise to sunset the owner, his daughter, and ranch hands worked hard to protect the purebred foundation stock from extinction. After years and years of diligent work their efforts paid off, they achieved their goal, and helped secure the future of the Texas longhorn cattle.

Aermotor 602 windmills were used throughout the ranch to pump water for the livestock and wildlife. They were simple and functional.

On a windy day, we could hear the creaking and banging away of the old windmill. We could see the blades of the wheel rotating while the tail moved in the direction of the wind. As the wind blew, the rod constantly moved up and down, pumping cool fresh water up from the water table below. As the water came to the surface it was channeled into an earthen pond for the livestock. What stood out in my mind was a tin cup hanging on a piece of wire at the base of another windmill located in the north pasture. Who left the cup and how long that cup had been there would never be told. I wondered if the cowboys left the cup by the water so they could get a drink as they rode from one pasture to the next, one windmill to the next, checking cattle. Or perhaps the owner of the ranch hung it on the windmill himself. The hand carved inscription on the cup read, "John 7:37— Let anyone who is thirsty come to me."

These distinctive original windmills, which we called the cowboy wind chimes, served as a landmark for our location on the trail and a spot for us to get cool water. We had a routine stopping point by a pond where we would dismount, rest, and eat lunch. Skipper always went with us and he especially enjoyed playing in the water while we ate. Hunting was not allowed on this part of the ranch so deer, hogs, doves, and quail would often be seen in the brushy area around the water.

Life had leveled out and I was happy working, being with my dog and riding my horse. Special times of prayer were spent on the back of my horse and peace was becoming a stronger part of my being. I chose to walk in unconditional love and peace of mind instead of the harshness and criticism that I was raised on. I was moving forward in the journey that God set in my heart.

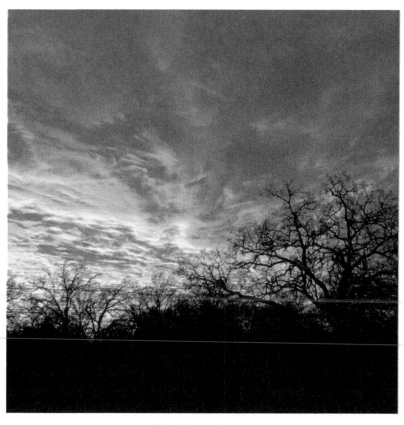

Texas Summer Sunset
College Station, Texas
T. A. McMullin

Chapter 6

A New Perspective

HOME LIFE HAD IMPROVED a little because I was now able to give some financial support to my father as well as do additional chores for him. Giving him a hundred dollars a month was my way of paying for room and board. I was thankful for a good job and a place to live. My siblings had moved on with their own lives so I was the only one left at home with my parents. During the 70s, times were tough and my father's business was hit hard by the economy. Being an unmotivated person, my father was content to just get by, to allow other people to take care of him, to do his work, and to pay the bills. His main concern was his welfare and his happiness. My life was much better because I spent most of my time away from the house.

When I wasn't working, I was at the barn with my horse and dog. There were lots of young boys and girls at the barn that needed some guidance in how to care for their horses and equipment. Soon I found a new interest when I started a 4-H club at the barn. Working with the local county extension agents, I taught the youth how to care for and train their horses, just like Mr. Luke taught me. This was a huge accomplishment for me and I was proud to become part of an organization that believed in helping young people to be the best they could be. As the 4-H leader, I spent time with the kids on a monthly basis, teaching them about proper horsemanship. I taught them how to saddle and unsaddle the horse in a manner that was proper and safe. I showed them how to use the reins and to be gentle with the horse's mouth. As a group, we talked about the importance of cleaning the horses' feet before turning them loose in the pasture.

Every few months we all worked together cleaning bridles and oiling saddles. We even talked about hanging the bridles and halters in a special place.

Arrangements were made by our 4-H club to have a guest speaker every other month. During our meeting time, we sat on square hay bales in the arena and listened to the speaker. After the meeting we ate lots of BBQ. This time of fellowship was exciting for all the members and their families as we talked, laughed, and had fun.

Parents were involved with their children in the 4-H activities. Once a year, the group put on an open horse show. Community members would come to the show just to watch the youth show their horses. A local horse show judge would judge the classes and select the top winners in each class. As the events ended, all participants gathered in the arena. There were trophies, belt buckles, and certificates to be handed out. Each participant received an award followed by cheers from the crowd. I stood in the middle of the arena to personally praise and encourage the youth for their hard work.

The national 4-H organization opened up a pathway of new experiences for me. I was exactly where I needed to be. Every once in a while, 4-H members and I would attend clinics that were sponsored by the Texas Agricultural Extension Service. I not only learned more about training horses but also about the Animal Science Department at Texas A&M University. Dr. Jones, the professor who put on the clinic, spoke with me personally and said, "You are the type of person we would like in our Animal Science Department." No one had ever said anything like that to me before. I didn't immediately realize the spark it kindled inside of me to attend Texas A&M University, but the desire to learn and to be successful suddenly overpowered my reading disability.

As time went on, I realized more and more the importance of getting a college education. One day when Miss Lili was visiting my mother at our house, she asked me what I wanted to choose as a career. I

quickly replied, "I want to go to Texas A&M University and work with animals." Miss Lili was excited and interested in talking further with me about college. She and I were kindred spirits, as we both were animal lovers. She often told me how proud she was of me.

As soon as Miss Lili left our home that day, my mother chastised me by saying, "You just embarrassed me again. There's no way in hell that you'll ever go to college!"

How quickly words of affirmation can be snatched away. Very quietly within my spirit I heard the words, *"He made you in His image."* I turned and walked away and took with me an added determination to keep moving forward in life and to accomplish my goals. Criticism was not going to create a stumbling block to keep me from being or doing better.

Kind words from Miss Lili continued to be scattered in with the harsh words from my parents. Every time I saw Miss Lili, she would encourage me with positive words that kept a small flame of hope burning within my heart. These words I treasured, as I did not hear many people say they were proud of me.

Words of affirmation have the power to break chains and heal many wounds. Gentle words spoken so tenderly are hidden deep inside of my being and are some of the best gifts I have received. With every ounce of my being, I wanted the Lord to be proud of me.

Through the years, the words of encouragement from Miss Lili continued to lift me up spiritually. I remember what she always said, "With God's help you can be anything you want to be. Just talk to God, trust Him to guide you as you go along in life." Miss Lili understood my heartache and the loneliness and rejection I felt. Miss Lili also reminded me, "You are God's child. You are not a mistake. He created you in His image and He loves you dearly."

During my younger years, I cherished these visits with Miss Lili. I learned from her that people walk through hurts, betrayals, emotional

pain, hardships, and discouragement. But, through it all, God's "mercy drops" are always there. Sometimes, we aren't even aware of mercy shown by God and by others, but mercy is always sprinkled throughout life. I learned that a daily walk with Jesus is the answer to all the questions. God will make a way. He will provide opportunities when we walk with Him and ask Him for guidance. It is through our relationship with Jesus that we can find meaning in life. Advice from Miss Lili helped me learn how to face life with stronger courage and a new perspective.

Chapter 7

A Step Forward

WITH A FLAME IN MY HEART and the momentum to move forward, I enrolled in a local junior college. Because I needed to attend college during the day, I transferred my job to a small animal emergency clinic that was open all night long. Working at night while going to college, I took the basic math courses from one of my mother's golfing friends. Mrs. Smith just happened to be the head of the math department at the junior college. She was an excellent teacher and spent time with the entire class, teaching math from the simple to the complex. As a result of Mrs. Smith's class, I began to understand mathematics and earned As in all classes related to math. Knowledge gained from Mrs. Smith would later carry me through calculus and statistics. She was so successful in teaching mathematics that her teaching style was published by Merrill Publishing Company and used in colleges across the United States of America. What a blessing from God that Mrs. Smith was aware of different learning styles. She understood dyslexia and presented mathematics in a way that I could understand. She was a teacher at heart and truly cared about each of her students.

My class schedule was set up so that I would be finished by noon, which gave me time to go to the barn and take care of my horse in the afternoon. The animal emergency clinic was close enough to my house that I could go home after I left the barn and study a little before Skipper and I went to work. The manager of the small animal emergency clinic was Fifi Faust. My new boss set the work hours for the employees and maintained schedules for a rotating staff of forty

veterinarians. Fifi was very helpful in setting my hours so I could work nights and attend college during the day. She made sure I had some time off on the weekends for my 4-H activities.

During the evening hours at the clinic when we were not real busy, the veterinarians would often have their families visit and bring food. Usually, the families brought extra food for the staff, which made for a nice working environment. I especially enjoyed working with the veterinarians that had a mixed large and small animal practice. We would talk about horses and cattle in particular. One of these veterinarians told me about a horse that needed a new home. Its owners were divorcing and were feuding over the horse as well as other assets. Neither one, however, wanted to accept responsibility nor ownership for the horse. Therefore, the next destination for this majestic animal was the auction barn where he could possibly be sold for slaughter. This story wrenched my heart. I told the veterinarian I would give the horse a good home, and so I did. The sire of the horse came from the Sioux Indian reservation in the Dakotas. With a heritage such as this, I decided to name him Joseph Spotted Cloud. This beautiful appaloosa gelding who was a dark bay in color with a white, snow-capped blanket and large, black peacock spots simply became known as "Cloud." Many happy hours were spent on the back of Cloud, and we enjoyed each other's company for the next thirty-six years. He was such a willing companion; always enjoying whatever trail we were riding on.

Fifi became my new riding partner as I rode Chief and she rode Cloud. Fifi was a feisty lady, cowgirl tough and so short she couldn't see over the top of a five-foot fence. She trusted Cloud enough to climb up on a ladder so she could mount and ride this sixteen-hand gelding. Although 22 years my senior, my friendship with Fifi was as solid as the horses we rode. We never rode off without checking to see if the girths were tight and the reins were even. Looking each other square in the eye, a simple smile and nod always occurred before the horses took the first step. Skipper stood in the background barking as he impatiently waited for us to walk forward.

Fifi and I rode horses together every weekend and we became the best of friends. I was grateful to have a friend who encouraged me to better myself. Dressed for the occasion, Fifi always wore black western boots, a custom made silver belly Stetson hat, starched jeans, and a long-sleeved white shirt. My normal attire was simple, worn-out boots, Wrangler brand jeans, long sleeve t-shirt and a baseball cap. Together, side-by-side, we rode for hours, enjoying each other's company, and sharing stories about her younger years living on the King Ranch.

Fifi was proud to grow up on the legendary ranch. She enjoyed telling me about the size of the ranch and the running W brand she would see on the magnificent Santa Gertrudis cattle. Fifi was allowed to ride anywhere she wanted to on the ranch. Often times she would ride by the ranch headquarters to see the beautiful foundation-bred Quarter Horses or to watch the cowboys gather up the cattle herd for branding. Her family lived on the ranch in the Humble Camp. The Humble Oil Company built small tracts of wooden framed houses in a simple fashion for the employees who worked on the oilrigs. Fifi's father, an oil field worker, had a difficult and dangerous job that included long, hard hours of manual labor. Mr. Faust was a small-framed man, physically and mentally tough.

Chapter 8

Resilient Through Struggles

MY BURNING DESIRE TO ATTEND Texas A&M University never wavered. I continued to work nights and attend junior college during the day. I applied to Texas A&M on several occasions but the man in charge of registration and entrance into the university, Mr. Davis, said my grades were not good enough for their college. Mr. Davis told me if I brought my grades up he would allow me to enter on a probation status. After each semester at the junior college, I would drive to College Station to show Mr. Davis my grades. His response was always the same, "When you bring your grades up, I will let you enter on a probation status." I signed up for more classes at the junior college and continued to work hard to bring my grades up.

My efforts finally paid off and I was able to maintain a low B average. After three different visits over a year and a half period, Mr. Davis told me, "It is time to cut bait or go fishing."

I knew exactly what he meant and my goal was in sight. Entering on probationary status, I had only one chance to prove myself.

I was excited and scared all at the same time. By this time in my life, I was becoming resilient in facing my struggles, realizing that life is just one challenging event after another, even within the will of God.

The next challenge was figuring out how to pay for tuition and living expenses for my first semester. Putting pencil to paper and trying to bring the ends together financially looked like an impossible task. I consistently thought about my financial situation—especially while I

was riding my horse. I needed someone who could give me some advice. One couple in particular, the Reeds, were extremely nice to me and sometimes we rode together on the TL-7 ranch. I mentioned to them that I was working my way through college and my goal was to obtain a degree from Texas A&M University. During our conversation I asked Mr. Reed if he knew how I could get a student loan. He told me to talk with my bank officer and see if I qualified. Mr. Reed requested that I let him know what the banker said.

The next time I saw Mr. Reed he asked about the outcome of the meeting with my banker. With a lump in my throat I replied, "My bank turned me down. They said I did not have enough security to guarantee repayment of a loan." Then I said, "You know, Mr. Reed, I will get through college on my own. It may take me twenty years, but I'll make it. Thank you for your concern."

Surprisingly Mr. Reed replied, "Terry, I am a banker. Come to my bank and complete the necessary paperwork for your loan. Once your paperwork is completed, I will present your case to our bank committee for approval."

My eyes filled with tears. I shook his hand and said, "Thank you sir. I will be at your office first thing in the morning. Thank you."

Within a month, I had my first student loan. Eager to become an Aggie, I packed a few belongings in my truck, stuck my new Aggie parking sticker on my windshield, and drove away from the past of my childhood to my new destination. Three hours later, my dog and I arrived at our new home in College Station.

I spent the first week going to class in the mornings and looking for a job in the afternoons. Within a week, I had three jobs. I was hired to work on campus at the dairy farm. My duties included gathering, feeding, and milking the Holstein cows that were raised on the university's four hundred acre dairy farm. I was used to working late evenings at the animal emergency clinic but at the dairy I would arrive at midnight and work until the morning hours.

It was difficult working the midnight shift during all types of weather conditions. Being true to Texas spirit, the weather could quickly fluctuate from wet to dry, hot to cold, or calm to stormy. Regardless, those cows had to be fed and milked twice a day. After being brought in from the pasture and fed, the cows would slowly move toward the milking parlor. The Holsteins were creatures of habit and knew the routine. After eating, they lined up and waited to enter the parlor. One by one they would walk to the next open stall so they could be milked. Each cow was cleaned and checked for mastitis before the automatic milk lines were put in place. On a good day, I would finish milking one hundred cows by seven in the morning and be ready for class by nine. When the weather conditions were cold and rainy, I would leave work and go straight to class. It was those days that I sat in the back of the class.

Strong coffee was always brewing in the milking parlor. Just a few steps away were the holding tanks of fresh milk. A little bit of milk made the coffee just right and my job a lot easier, especially between the hours of two and four in the mornings. One day a week, I worked at the beef center helping to feed the young heifers. My friend Fifi made arrangements for me to work a few hours on Saturday evenings at the animal emergency clinic. She knew this would help me pay for my gas and meals over the weekend.

Weekends were special to me because I was able to see and ride my horses that I had left with a trusted friend. Leaving them behind was not my first choice but they were safer with my friend until I could get established in my college location. Sometimes, our second choice turns out to be our best choice. My goal was to have my horses with me as soon as possible. Fifi would ride with me on Sunday afternoons when she could. Her parents' health was declining and Fifi was making arrangements to relocate to a small community in East Texas. Together as a family they wanted to move back to the roots of their younger years. Fifi's strongest desire was to care for her parents. Mr. Faust, needed only basic care, but Mrs. Faust required personal care and supervision as her mother was becoming more and more

forgetful. In my heart, I knew this was the last time Fifi and I would ride horses together.

Every Monday morning, I would drive back to college for class at nine o'clock. This rigorous schedule continued for a year and a half before I moved to a working cattle ranch about ten miles from campus. My fancy hacienda was a converted chicken coop with one bedroom and one bathroom. I might exaggerate and say the total space was every bit of three hundred square feet. A barn sat conveniently right behind my house and I was able to rent two stalls for my horses. I worked on the ranch during the afternoons and weekends in order to cover the cost of rent, horse feed and living expenses. Student loans covered tuition and books. No longer did I have to drive two hundred and fifty miles each weekend to work and to see my horses. Sometimes I even had an extra $25.00 and I thought I was rich. I gave the $25.00 to my church or a stranger in need simply out of gratitude for what God had done for me.

Chapter 9

Rewards of a Good Education

MY EDUCATION WAS EARNED the hard way and college courses were challenging. Because of my dyslexia, I had to work ten times harder than most students. Libraries became my second home where I spent hours researching and learning material I had not understood in high school. After completing the basic course work, I was ready to take classes in the Departments of Agriculture, Animal Science, and Agriculture Education. By this time, I had friends I could study with. When I needed to write a paper, I would ask my friends to look over my writing and make corrections.

I developed my own system that helped me comprehend the assigned reading in a way that would be productive. I color coded the important information and then developed my own outline for memorization. I studied the outline over and over until I could see it in my mind. Studying involved memorizing the formulas and writing them over and over. Writing out mathematical formulas and calculations on paper helped me to learn the abstract material.

When it came time for the test, I would write out the formulas on the test before answering the first question. This helped me to focus on the questions without having to think about the correct formula at the same time. Because I wrote out the formulas, I had a visual focus of which one to select in order to answer the question. I always read the question three times. The first read was to comprehend what the

67

professor was asking. The second time was for underlining key words or phrases. The third time was to make sure I had the correct answer. Multiple-choice questions took longer to answer than true or false questions. I preferred it when the professor simply asked straightforward questions in the form of a list or short answer type questions.

If I had to write a paper in class, I used small words that I could easily spell. My handwritten papers involved a thorough process of planning an outline of key points. I wrote down the key points on the back of the test so that the professor would know I did this in class. After developing my outline I then wrote my paragraphs. I had to think and write fast due to the time frame. If the paper could be done outside of class, I would develop an outline before starting my paragraphs. Then I worked on a draft copy until I was satisfied with my thoughts and writing. The last step was to handprint my final copy before paying the secretary in the animal science department to proof and type my paper.

When it came to spelling, all bets were off. Spelling was a challenge but I was never too far from a dictionary. All of this studying took extra time but it paid off for me because I made As and Bs. Those times were difficult, as money was scarce and studying was strenuous, but it was a small price to pay for the rewards of a good education.

Step by step and class by class, I was completing the required hours and course work needed to earn a Bachelor of Science degree at Texas A&M University. Finally, I earned enough credits to have the honor of ordering my senior ring. When I received my ring, I stood and looked at the shield, the thirteen stripes, the five stars, the eagle, the wreath of olive and laurel, the cannon, saber, rifle, and the flags on my ring. Each of these symbols stood for a value that an Aggie should hold. I knew that the five stars on the shield represented: mind, body, spiritual development, emotional poise, and integrity of character. Overall the ring portrayed a strong set of values: excellence, integrity, leadership, loyalty, respect, and selfless service.

I thanked God for providing a way for me as I proudly placed my Aggie Ring on the ring finger of my right hand. Hard work, diligence, sacrifice, and determination were the unseen values that made my ring possible. I believed in myself and that big ideas and dreams can become reality-one small step at a time.

Earning the credits for student teaching was the only thing left for me to complete before graduating. Little did I know that my student teaching would have an ever-lasting impact on my life. I gained friends and a lot of experiences that would make me a better teacher. I had the opportunity to student teach in a small farming community with a "wise steward of the land," as my mentor.

I remember calling Mr. Turner to inform him that I would be doing my student teaching with him for the fall semester of 1982. He replied, "That is fine, you are the first female agriculture student teacher that I have had."

The next day, I went to visit and meet his family before my teaching was to begin. Mr. and Mrs. Turner were very nice and made me feel welcome in their home and in their community.

After I completed the first day of student teaching, Mr. Turner said these words to me in his no-nonsense way of saying things. "Terry, if you go out drinking and dancing with the boys, do so in another community!"

I quickly replied, "You don't have to worry about me. I don't drink and my social life involves my animals and church."

Mr. Turner said, "Good. We'll get along just fine." And, fine we did. Little did I know on that first day of teaching, that this teacher and his family would become dear lifelong friends.

Hands on, practical experience from my mentor in the classroom helped prepare me for future years of teaching. Mr. Turner took great pride in restoring farm equipment. The agriculture mechanic

students were inspired by his knowledge and method of teaching. There was no time for boredom or restlessness as the learning style was full of greasy hands and a lot of soap. One major project was the rebuilding of a John Deere 1940 H model tractor. Piece by piece, the old tractor was dismantled, labeled, and placed on the shop floor. Pieces were cleaned, polished by hand, and inspected for wear. Every piece was touched and inspected by each student as part of the learning process. Once the repair was made, the parts were then primed and repainted in the original color. It was impressive to see this old tractor rebuilt and restored to perfect condition. Painted in John Deere green and yellow, this seventy-year-old tractor always started the first time. Upon the completion of this class project the tractor was named "P.J." for Popping Johnny because of the unique sound it made once the flywheel was turned and the engine started. When not being used to pull a rake in the hayfield, this antique John Deere tractor had a protected home in an enclosed barn.

I learned much more about farm life outside of class. For example, Mr. Turner took pride in showing me his pecan grove and explaining to me the technique he used to graft his trees. He explained how he selected a young limb for grafting. I was fascinated with the discussion as we talked about different techniques for cutting an inlay pocket so that the bud stock would be firmly held in place. He explained that the graft should be done on the south side of the tree so that prevailing winds would blow against the new graft.

Standing next to the huge trees that were grafted over thirty years ago, we both reached down and picked up a pecan. I said to him, "I admire the fruit of your labor and your knowledge of how to care for the land." I enjoyed every minute of my student teaching with this fine man.

When I think of Mr. Turner, Texas A&M class of '60, I think first of his uniqueness in teaching, his ability for rebuilding farm equipment, and most of all his love for the prettiest mama cows in the land. Even

though he is now in his middle eighties, I still enjoy teasing my friend by asking him if he would like to go horseback riding with me.

Mr. Turner always, always, replies back, "No! Horses are useless! I had enough riding when I was young. I had to ride a horse to work cattle. I had to ride a horse to check fences. I had to ride a horse just to go anywhere. I had to ride a horse to go to school. At school, I tied my horse to the hitching post and then I'd ride him home after school if he was still there." Laughing, he goes on to say, "I'll ride in my Ford truck today." His laugh makes me smile and warms my heart.

At last, at the age of twenty-eight, ten years after high school graduation, I reached my goal. Proudly, I walked across the stage at G. Rollie White Coliseum to receive my Bachelor of Science Degree. When my section was called, I left my seating area and stood in line with the other students in the Department of Agriculture Education. When it was my turn I climbed up three steps to the stage just in time for the president of the university to announce my name. My pace was slow and steady as I reached for the diploma with my left hand and shook the president's hand with my right hand while continuing to walk across the stage. Inside, however, I was jumping up and down, turning somersaults, and shouting for joy. Sitting in the audience was my ninety-year-old grandmother, who was turning mental cartwheels with me. After receiving my diploma, I thanked the good Lord for a praying grandmother, one who never lost faith in me. I was beginning to understand that God had a bigger purpose and a pathway for my life.

Chapter 10

Freshness of Gratitude

THE DAY AFTER GRADUATION, I called Fifi to tell her I had earned my college degree. My phone conversations and visits with Fifi were few and far between as we no longer lived close together. She and her family had moved to the piney woods of East Texas years before. Instead of managing a staff of veterinarians, Fifi took on a new role as the caregiver for her father and mother, perhaps the hardest job she had ever had. Even though I thought of my friend a lot, I knew she had very little time to just visit and in all honesty, I did not have a lot of extra money to cover the long distance phone charges.

Graduation was an occasion that I just had to tell Fifi about. As soon as she picked up the phone, in one long breath, I said, "Fifi, I just earned my B.S. degree, I graduated from college last night, and I have the opportunity to work on a M.S. degree."

Jokingly, she quickly replied, "All you need now is a J-O-B." I knew she was proud of me and together we laughed and talked like there was no timespan since our last conversation.

She told me she was glad I caught her in the house as she had just returned from her walk by the lake. She said, "I'm sitting by the open fireplace with mother drinking a cup of coffee. Dad is outside looking at his tractor. I wish you were here with us. You and I would take our coffee and go to the lake and watch the deer." I asked Fifi how her mother was doing. In short statements, Fifi replied back, "The last fifteen years have been a slow decline... It's been a long goodbye from the mom I knew... at times it broke my heart... It's my honor to care

73

for her. I try to walk in the woods early in the mornings to gather my peace of mind."

I knew exactly what Fifi was saying. She would walk to a spot set back deep in the woods, along a lane, to their two-acre lake. Camouflaged by the trees was a campfire area with a hand carved wooden table with three matching chairs facing the lake. This was the place where Fifi said she often went to sit, think, and drink coffee. It was the place where she gathered together her strength. She told me how the pink and red color of the sunrise would filter through the trees as the morning dew touched the ground. Oftentimes, deer slowly made their way from the thick brush to play and drink water by the lake. They would run in and out of the waters' edge, causing ripples to appear. Minutes later, the water would calm when the deer walked away and headed back into the deep woods. Fifi enjoyed just watching the simple, peaceful things in life. Like me, she had a special bond and kinship with nature.

I knew deep inside that calmness and peace at the dawn of day was essential for Fifi as she prepared for the coming hours of caring for her parents. She knew that life was full of ever changing moments quite often out of her control. Mrs. Faust's health was failing and Fifi, an only child, was on her own to care for her mom and dad. Fifi often told me, "You know Ter, (she called me Ter) life at its best is tough."

Many times my reply was, "I've heard that saying more than once." I knew my dear friend understood emotional pain, as life seemed to have dealt her a rough hand.

With a cantankerous determination, Mr. Faust had his own way of doing things. Sweet spirited Mrs. Faust was now in the late stage of Alzheimer's. Fifi herself suffered from chronic painful joints and inflammation associated with lupus, a long-term autoimmune disorder. Yet, with these huge challenges, Fifi remained loyal to caring for her parents. Daily, she would bathe her mother, fix her hair, brush her teeth, wash her clothes, and feed her. She prepared

three meals a day and cared for her parents' individual needs. Every Sunday, Fifi faithfully drove her parents to church. Leaving the church service, Mrs. Faust would say to the preacher, "I don't know who this little lady is, but she takes real good care of me." This was only one of many moments that stole peace from Fifi on a daily basis.

From the time I told Fifi that I received my college degree I made a promise to myself to call and check on her and her family more often and help her as much as I could. Fifi made my life better just by being my friend. My family was built one friend at a time and Fifi and I were longtime friends. I was thankful to have good friends that filled in the lonely gap created by the ones that raised me.

After graduation, I continued to live and work on the ranch. It was no longer an option for me to go back to my hometown. I was happy on the ranch and had plenty of acreage to ride my horses on. I actually took a week off to rest and think about where I wanted to work and what I wanted to teach. I spent some of that time filling out job applications and searching for open positions as a teacher or as a county extension agent. I wanted to stay near College Station so I could work on my Master's degree in the evenings after work.

Within no time, I was offered a job as an agriculture science teacher in a rural public school forty-five minutes from the ranch. The location was perfect for me because I did not have to move and I could drive back and forth to work. I thanked the good Lord for providing the way for me.

In order to gain a better understanding of my students and the community where I would be working, I drove to that school on a Saturday afternoon to just look around. As I drove around town, visually I discovered that the population varied from the extremely poor to the wealthy. The poor lived on the west side of town and the wealthy on the east.

Just before arriving on the main street, I saw a sign that read, "Home of the largest cotton gin in the world." That sign told me that cotton

was the major cash crop grown in this area. In the days when cotton was king in Texas, the Texas Central Railroad played a big role in the transporting of the cotton after it was cleaned in the gin. The site of the old cotton gin was now covered in weeds and brush, but the railroad tracks remained in place.

The cotton gin site was a landmark for the road that led straight to the school. At the sign, I turned right and crossed the tracks. A short distance later, the school building was in sight. Next to the school was a neighbor plowing his garden for a new crop of vegetables. As I pulled up to the building, the neighbor stopped his tractor. He came over, introduced himself, and discovered that I was the new agriculture teacher. I found out from him that the community was one of extreme opposites with prejudices set in place from long ago. The foundation families sent their children, in a passenger van, to a private school in the area where I lived. The families that lived on the west side sent their children to the local public school. Those students either rode the school bus or walked to school. They were not allowed to walk through the neighborhood but up and down one set of streets only. This was enforced by the school administration and the local law enforcement agency.

My teaching assignment involved teaching two classes of basic agriculture science and a basic horticulture class. The remainder of the day was set aside for agriculture mechanics, welding, and projects. Teaching these students was a huge challenge as they had a history of being disrespectful to teachers and school officials.

After the first week on my job, I realized many of my students could not read high school material. Understanding their frustrations, I provided reading material on a third grade level with additional visual and hands on activities. Rather than stand and lecture, I would sit with the students and work on assignments as a group. Each of us would take turns explaining the material to one another. It took much effort to gain their trust and respect, but over time the students began to

enjoy learning. It was exciting to make progress in the lives of my students.

A few minutes before the end of each class I would ask the students to set one goal for the next day and think about how they would accomplish that goal. We talked about goal setting and about the roadblocks, negative thoughts, or people that could possibly keep that goal from being accomplished. Each Friday, we had a gratitude minute, where each student said five things they were grateful for on that day. On Mondays, we all wrote down five positive things that happened over the weekend. In time, they began to understand the freshness of gratitude and being thankful even for the little things in life. Even the phrase "thank you" was becoming a part of their thought pattern. I joined in with the thankful, gratitude discussion. As simple as it seems, a fresh cup of hot coffee was part of my gratitude every morning. I was grateful to have the opportunity to earn a college degree and become a teacher. I expressed to the students that I was thankful to have the opportunity to teach them. Over time, many of the students began to believe in themselves and see that they could accomplish their goals and their dreams.

One student in particular, Joshua, a senior at the time, set a goal to attend college and to work in the field of agriculture. His parents and family members were hard working, gracious people but did not have the financial means to pay for college. As a family, they encouraged Joshua's dream and desire. Joshua turned his attitude around and worked hard to make good grades. After graduation, he received a local scholarship for the most improved student. I am proud to say Joshua accomplished his goal, graduated from Prairie View A&M, and went to work for the United States Soil Conservation Service. Our paths cross every so often and after a hug, Joshua always thanks me for helping him to gather the courage to make his life better. I know he, in turn, passed on his inner determination to the people around him.

Chapter 11

Strong, Silent Faith

AFTER A FEW MONTHS OF TEACHING, I attended college classes once again and worked toward receiving my Master of Education degree. It was a welcome relief to work only one job while attending class on Tuesday and Thursday evenings. I enjoyed the classes on a master's level as the subject material was geared toward my professional career. For once, I had the time to stop and visit with my classmates without feeling pressured to go to work or to study.

One classmate in particular, Kurt, stood out in my mind. He was a hard worker and was quick to lend a helping hand to a stranger. During the week he attended college, but on the weekends he returned to his family ranch to help work cattle. Many times during the school week, Kurt would come to my farmhouse to just sit and visit. I have such good memories of those simple visits. We would sit on the front porch, drink coffee, and talk about his cattle, what calves he had on the ground, and his cow dog, Junior. Kurt was proud to be an Aggie and looked forward to owning his own ranch someday. Little did I know that the few months I was around Kurt would have such a strong impact on my life. Even today, when I look at his picture I see a young man who showed me that there are fine, Christian men in this world who are family oriented, love animals, and appreciate the ranching heritage.

I had the opportunity to meet Kurt's family and see their ranch. His father was a preacher and a rancher. His mom played the piano at their church and led the ladies' weekly Bible study class during the weekday. On the weekends in church, Kurt and his sister were youth

leaders. Together, this entire family stood strong and loved the Lord with all their heart and mind. I was proud to get to know this family.

Kurt was a tall, straight-laced cowboy who wore custom made, high top western boots—no fancy brand, no fancy stitching. Kurt always wore a long-sleeved shirt no matter the weather, no matter the temperature. The color of his hat would vary from time to time, but the smile on his face and the gleam in his eye never changed. What you saw of Kurt was who he was—just plain and simple. He was a twenty-five-year-old man of strong, silent faith, a man who had a deep connection with the land. He treated every one with kindness, generosity, and fairness. He encouraged those around him to be their best and to do their best. He silently disapproved of ill behavior and stood strong for what was right.

My last conversation with Kurt will forever be a special memory etched deep in my heart. Before leaving to go home Friday morning, Kurt called to tell me he had my book on The Principles of Horseshoeing and did I need it.

I said, "No I'll get it from you next week. Have a safe trip. Tell your folks howdy for me."

He replied back, "I'll be at the big ranch house if you need me."

I didn't think too much of those departing words until I received a call from his sister, Pauline, late that same evening. I answered and the voice from afar said, "Terry." There was silence before Pauline spoke again, "It's Kurt. He's dead."

I was stunned and couldn't speak. Silence, disbelief, and sorrow hit me all at once. Through tears, we tried to talk and comfort each other but comfort did not come.

Kurt knew his life was in God's hands. Into the hands of Jesus, Kurt was prematurely scooped up from this earth to a mansion, a big ranch set on high. Tragedy can strike in the midst of the calmest day with

the bluest of skies. Kurt, an experienced pilot, often took off in his plane on Friday mornings to fly home to be with his family. Ten minutes after taking off, a dense fog suddenly settled around the plane, thus blocking Kurt's orientation to the visual horizon. So, instead of climbing up out of the fog, Kurt became disoriented and descended into the ground. My dear friend, my brother in the Lord, died two months before receiving his college degree.

Kurt was loved and respected by many. This was evident as there was standing room only at Kurt's funeral—actually, there were over a hundred people standing outside the church to pay their last respects. I was one of those standing outside in the cold and misty rain singing, "Blessed assurance, Jesus is mine...all is at rest...echoes of mercy...lost in His love." Kurt's father preached his son's funeral, sharing through his own heartache that Kurt was the salt of the earth. What a wonderful analogy. Salt is a symbol of peace and friendship. Salt enhances the flavor of food. Yes, Kurt was salt and much more to those who knew him.

Through tears, Kurt's father went on to say, "In knowing my son, you knew honesty, integrity, and what true respect was. Kurt embraced what we strive for in our own daily living—to be generous and kind to all. Kurt was a true gentleman with a sincere relationship with God and a deep everlasting love for his family and his friends." In closing, Kurt's father encouraged us all to live with integrity in our heart and blaze a trail of unconditional love, kindness, and generosity. Each effort, each act of love, kindness and generosity makes a difference just like it did in Kurt's life.

Leaving the funeral I said to myself, "I know that someday, when the Lord calls me to my big ranch on high, I will see Kurt again." In my mind, I can picture Kurt sitting on his big grey Quarter Horse gelding saying, "Howdy, class of '84," to me. With a big smile on my face I will hug him and say "Class of '82" to my dear friend.

On the long drive home, I thought about the prayer that I said when I was younger. In the beginning, my prayer was a cry for help and now I can see the gratitude in my life as the Lord answered my prayer.

Lord, I want to be what You want me to be...
I want You to be proud of me...
Lord, help me walk through the valley so low to the top of the highest hill.
Lord, I want to travel the journey You set before me.
Please hold my hand and help me to live in the center of Your will.
I need You, Lord, and I want You to be proud of me.

In the center of God's will there are struggles and the journey is not always smooth. God is there to hold our hand and to carry us through. Hardships come to all of us as we walk from the valley so low to the top of the highest hill. We are all set on a journey, a journey to find peace in the center of His will.

Chapter 12

Moving Forward in Life

LIFE GOES ON WITH ALL of its ups and downs. I continued to teach agriculture for the next school year but driving back and forth to work was getting expensive and the maintenance to keep my old truck running was increasing. I was still attending classes two days a week to complete the requirements of my Master's degree. One of the lessons I learned in the foster home was that I had to take care of myself while planning for the future. Getting a newer vehicle was not an option because I needed to pay off most of my student loans before borrowing more money. Staying out of debt was part of my plan so I began to think about changing jobs to save time and money.

Keeping my truck in one piece was a challenge. The gas tank had one small hole that was plugged with a screw so it would not leak. Two gallons of water were always in the bed of my truck ready to be poured into the radiator when it overheated. The springs were sprung and bouncy which made for a great ride over the railroad tracks on my way to and from work. After the transmission started slipping, I became more serious about working closer to home.

Every weekday, while driving to work, I passed the passenger van going to the private school and wondered about teaching in a Christian school environment. Following through with my thoughts and asking God for His leadership, I resigned from teaching agriculture at the end of my school contract. Believe me, I prayed hard about my decision. My back-up plan was to work on the ranch until I could find another teaching position. The one thing I never

wanted was to be out of God's will. With hindsight being twenty-twenty, the right choice was made.

Looking back, I can remember completing my application at the private Christian school and the interview process with several of the school administrators. I was asked questions about my teaching style, personal experience and how I would handle a mischievous student. I explained to the interview committee that I had an inward calling to teach. My teaching style was to connect, to bond with all my students on an individual basis and to meet their individual learning style. I talked about my experience as a 4-H leader and an agriculture science teacher, explaining that it was my job as a teacher to be a good role model, spark the student's desires to learn, and to encourage the greatness that lies within.

During the interview, the headmaster asked me to comment on my professional and personal goals. I replied that I wanted to be available for my students, to have their trust, and to present material in a manner in which each student could learn. My personal goal was to daily become a better Christian, to live with integrity in my heart, and blaze a trail of unconditional love, kindness, and generosity.

I explained that I was working on my Master's degree in Education in the evenings two days a week and would be finished in about a year. I left the interview feeling that this school would be a good match for me. The headmaster said he would get back to me within two weeks with his decision.

Although the next fourteen days seemed like an eternity, the headmaster kept his word and I was offered a job as a science teacher. I was so excited about the new job that I stopped cleaning horse stalls and immediately went to his office to sign my contract. I parked my old truck next to the new, shiny passenger van that transported students from my former teaching location. I chuckled as I thought about the irony of this situation, as now I would be teaching

the "other" group of students. Having this new position just a few miles from home was an answer to prayer.

The Sunday before I started my new job, I called Fifi. I wanted to tell her about my new job and to see how her mom was feeling. When I had spoken with Fifi two weeks earlier, Mrs. Faust had an upper respiratory infection. I was concerned, knowing her health was fragile. After ten rings, Fifi picked up the phone and said hello in a sad, broken voice. I said, "Fifi, this is Ter, how is..." and before I could finish, Fifi replied, "Mother passed away in the hospital on Monday. Mother is out of pain and the pain in my heart will ease in time."

Together we cried and I asked her what I could do to help. Fifi asked if I was okay and I said, "Yes. I start my new teaching job tomorrow and when we talk again I'll tell you more about my students and my job duties." Our short conversation ended with a prayer.

One of my duties as the science teacher was to be in charge of the local science fair every spring. The first thing I did was to try and gather resource material concerning science fairs. I asked other science teachers and some of my college professors if they had anything useful for me. Very little information was available. During the evenings, while working with my horses, I would think about the science fair and ponder the process. I had a lot of thoughts running through my mind. Finally, I decided that I would develop my own curriculum, a simple step-by-step process, for teachers in charge of a science fair. This would help teachers to plan, develop, and produce a science fair.

One day after work, I called Millie, a colleague of mine, to share my idea with her. She agreed that there was not enough information on this subject. We continued discussing science fairs and I said, "Well, why don't we just write a book about it!"

She said to me with disbelief, "You gotta be kidding."

I said, "If you don't sit on the horse you'll never know if he bucks or not." I reminded her that she had once been an editor with a famous historian and writer in Canyon, Texas. With great boldness, I said, "With my idea, drive, and scientific background and your experience in editing and writing, this task can be accomplished."

And, accomplish it we did!

Seeing my name on a book as a published author had been a dream of mine for many years. Millie began to visualize that dream for herself. Never mind that neither of us owned a computer, knew anything about publishing, had detailed knowledge about science fairs, or had any extra time to spare. God solved our dilemma and began to open doors for us. Our main problem was solved when an acquaintance offered his office and his computer for us to use during the evening hours. Since I was still attending college classes on Tuesday and Thursday after work, we scheduled Monday and Wednesday nights for writing. Usually, we worked until midnight and our new friend trusted us to just lock the door behind us when we left. We worked evenings, weekends, holidays and summer months blending ideas, words, and sentences together.

Millie was a reading specialist and loved words. She would sit at the computer with an open thesaurus looking up word after word. I was not allowed to look up words because it took up too much time, according to Millie. She taught me to stay focused in my thought pattern and writing technique. I learned so much by writing, rewriting, and replacing sentences with better ones. I saw how words were exchanged one for another, how the meaning of words was enhanced and a vivid picture brought to the page. Excitement was built word-by-word, sentence-by-sentence, paragraph-by-paragraph, and page-by-page as our book was being formed.

As we wrote and worked together, I learned about the basic rules of phonics and how to sound out letters. This was a lesson that proved over and over to be invaluable, taking my career and personal desire

for writing to an even higher level. Millie was the teacher that I needed in elementary school. Phonics was the missing link to my education and the key ingredient in dealing with dyslexia.

After months and months of focused writing, completion was in sight. I contacted Mrs. Smith, my friend and former math instructor, to ask her advice about the publishing business. She was excited to hear about our project and offered to write the foreword to the material. Having a published author endorse our material was another blessing.

The manual was designed so that the student and the teacher would have a comprehensive, step-by-step approach for the production of a science fair project. A checklist was provided for the student to promote their own self-discipline and responsibility in developing their project. Three different plans for the development of projects were listed. Students could select an area of interest in research, invention, or survey. Suggestions for selecting a project ranging from applied science to zoology, along with the steps of the scientific method for research were discussed. By following the step-by-step approach the students could then complete a research project plan to help them organize their actual project. A student checklist was designed to encourage each individual's responsibility for completing each procedure in a timely manner.

A checklist of monthly objectives starting in September and ending with the completion of the fair in April provided explicit steps and procedures. The manual presented activities in a carefully paced manner that was attainable by student and teacher. Topics such as budget, resources, committee development, displays, safety procedures, project plans, judges, presentations, awards, and the production of the actual science fair were arranged in a detailed order explaining the entire process.

Plans were also provided for a mock science fair in February so students had a chance to practice their presentation skills and to learn more about their projects. This also allowed the teacher a chance to

make any necessary changes before the production of the actual science fair. Invitation letters for parents, an exhibitor's list, and judging forms were made available to help the teacher in final preparations for the science fair. An award ceremony was last on the list so that all the students could celebrate their accomplishments.

After the completion of the fair, an evaluation form was provided to each student. This allowed for feedback in regard to the overall science fair process and suggestions for changes.

The next step for the winners was to prepare and attend the regional science fair in their area. This detailed Science Fair Manual was designed specifically so that any teacher could successfully plan, organize, and stage a science fair in their local school district.

After months of long hard writing, Millie and I sent out five query letters to educational publishing companies. The fruits of our effort paid off and the world's leading education publisher made us an offer and published our book, *Science Fair Manual—A Step-By-Step Approach.* Our material spread across the United States to every school district that used the Prentice Hall Science Curriculum.

Following this great accomplishment, Millie and I gladly accepted the opportunity to present our material to teachers across the State of Texas. We traveled on weekends and during the summer months from South Texas to the Panhandle and places in between. We were excited about our accomplishments and went on to write and publish material for the American Quarter Horse Association, *The American Quarter Horse Racing Journal,* and other magazines.

You talk about smiling and walking in high cotton! High cotton is a Southern term for having a great deal of happiness, success or wealth. My cotton was way high as I had all three. I was elated at the literary accomplishment, proud of our success, and rich in the Lord. I was blessed double time as the money I made from these accomplishments paid off most of my student loan. There was also

enough money for a down payment on a brand new, Aggie maroon colored, three-quarter-ton, heavy-duty, Chevrolet pickup truck.

The first thing I did after receiving copies of the book was to get in my new truck and drive one hundred miles to see my grandmother. It was impossible to explain the joy I felt as I handed my grandmother a signed copy of the book along with my Masters of Education Degree. As I thanked her for loving me, I recalled the encouraging words she had given me through my childhood. Many times she told me that negative words or criticism could not hold me down. She helped me believe that if I just did my best, then many obstacles could be overcome. My grandmother was right. Negative words, critical comments, and even dyslexia could no longer stop me from achieving anything I wanted. I had gathered the courage to move forward with my life, to walk through any roadblock that would keep me from achieving my dreams.

I continued to teach science for the next four years and to produce the annual science fairs. I built a wonderful rapport with the students and the staff. Community members became involved in the science fair and in the judging process. This private Christian school was like a family to me and I loved the people I worked with.

After school, I developed a horse program for several of the students who were interested in learning to care for and train horses. I followed the same gentle training methods that I learned from Mr. Luke and the ones I taught to the 4-H members back home. I bought a three-month-old registered Quarter Horse gelding, Zandy, so that the students could see firsthand how to train a young horse. Zandy was a grandson of the famous King P-234, the same bloodline that King, Mr. Luke's horse, was out of. Zandy was my pride and joy.

Daily, I worked with Zandy, training him one small step at a time. Because he was young, the students and I started Zandy with halter and lead rope training. With a simple movement of the lead rope, we then taught Zandy to walk forward, backward, and move from side to

side. The students watched and learned with practical hands-on experience. They all learned to clean out his feet and Zandy learned to pick up his feet on touch.

As Zandy progressed in his training, the students used a small hand towel as a brush to get Zandy used to the feel. We then progressed to a bath towel and then a saddle blanket. As the training progressed, we were able to put a kid's saddle on Zandy. Together, we all looked forward to playing with Zandy in the small arena as he walked and trotted over logs, tarps, and through puddles of water.

The horse program gained in popularity and Zandy turned out to be an invaluable teacher. The students learned responsibility and that kind, gentle horse training was effective. Zandy built a bond between the students and that was an added benefit to the job I loved so much.

Suddenly, my teaching career in this private Christian school took an unexpected turn. The second week of May, the headmaster called a special staff meeting and asked all the teachers if they would consider working for six months without pay for the following school year. After the six-month period, the board members would reevaluate the finances and determine if there was enough money for teacher salaries.

As teachers we couldn't believe what we were hearing. We sat in the room in complete silence trying to make sense of what had just been said. We felt betrayed, rejected, and saddened as the staff was a close-knit family and we had just received a death notice. In complete silence, one by one we left the room. Each of us had a decision to make. Within two months, our teaching family split apart as most of us had to leave and find other places of employment. Teaching at this school for the past four years was one of my favorite assignments, but I knew that I could not afford to teach six months or more without pay.

Chapter 13

The Voice in Your Heart

NOW WITHOUT A JOB, I immediately started searching and filling out applications for the following school year. I inquired at all the local schools for a position in the field of agriculture or science and continued to come up empty. I spent hours on a daily basis driving to schools within a thirty-mile radius and talking to personnel directors about job vacancies. I then expanded my search to a fifty-mile radius. The words, "Sorry, there are no open positions in agriculture or in science," were spoken over and over again. I prayed long and hard for guidance. Fifi's words, "All you need now is a J-O-B," echoed in my memory.

The same month, I was informed that the owner of the ranch was considering selling the property for commercial use. Although it was unsettling in my mind, I knew I would have some time to relocate to a place where I could live and keep my horses. I still had one more student loan to pay off and a truck payment so buying a place was out of the question. My mind was racing back and forth as I tried to problem solve on my own. For just a short moment, I doubted myself and was walking in the circumstance instead of courage. Courage is what I needed to get through this situation.

Life is full of constant change and how I chose to view the change would either strengthen or weaken the underlying core of what I believed. Finally, peace came as I stood up and told myself to STOP. Stop the emotional rollercoaster and wait on the Lord. Every evening after work, I would sit on the couch in what I called, "My Gift of Gratitude Time." I began with a prayer of gratitude as I verbally

thanked the Lord for three things I was grateful for that day. I was grateful for friends who cared, an automobile that worked, and for food on the table. The next day I was grateful for good health, a great Church, and for the ability to help someone else. My list of gratitude went on to thanking the Lord for loving me, for friends who showed me kindness, and for not having to live my life in a foster home. This was the beginning of "My Gratitude Journal." Each evening, after giving thanks for the blessings of the day, I just sat and waited on the Lord. No planning, no trying to figure out the how and why, I just sat quietly and waited on guidance.

Finally, inner peace and harmony began to settle in my soul. Slowly, I began to drift backward in my mind to the positive words of affirmation that gave me strength and courage during my childhood years. Miss Lili's words brought strength to my mind. "With God's help you can be anything you want to be. Just talk to God. Trust Him to guide you as you go along in life." I reminded myself, "I may be a simple person, however with the drive to succeed and the courage to press through the mud of life I can do extraordinary things." Words from my grandmother also echoed strong in my memory as I remembered her explaining the 23rd Psalms to me at such an early age. My grandmother would tell me "The Lord is your shepherd: you shall not want, He will give you lush, green, safe pastures, enough food, refreshing water, and wonderful protection because He loves and cares for you. He will restore your health and joy. He will restore your soul as you rest in His will. Trust the Lord to provide all your needs. He knows just what you need at the right time. Remember His time is not your time because He knows your life from beginning to end. He knows what is going to happen to you day by day."

My memory was strong as I can still remember her sitting next to me holding her red Bible and saying, "He will protect you from evil and will walk with you through the valley of the shadow of death. He will take care of you even in the midst of a stormy day. He will calm the storm in the day and the rumbling inside of you.

"He provides comfort for you and guidance to you. His guidance will keep you on a pathway full of goodness, integrity, and righteousness. Your pathway is set before you. If you stray, He will guide you back. He leads His children sometimes by a still, small voice. Listen to the voice in your heart."

My grandmother would always say, "The good Lord prepares a table for you in the presence of what may seem like trouble or conflict. He always provides abundant peace and protection in times of need or darkness. He is the one that anoints your head with oil and allows your cup to overflow with blessings. Stop and look for goodness and mercy, as it shall follow you all the days of your life. You will live in the house of the Lord forever and ever because of God's love for you."

A month before the headmaster's announcement about the financial crisis at the Christian school, I had agreed to a camping vacation with some of my friends in Wyoming. If I had known I was going to be unemployed at the end of the school year I would never have committed to such a trip. I also never imagined the ranch would be sold. I was not sure I could take several weeks off from my job search to take a well-earned vacation. Vacation had not even been part of my vocabulary before now. I had to sit down and talk to myself once again and focus on the strength of the Lord and his guidance. Then I told myself, "God has and will take care of you, just relax and have fun. You'll find a job when you get home. You might just find a new home while you're looking for a new job."

Still talking to myself, I said, "Start packing and get ready to go camping." So I picked up the phone and I called Millie to see if she wanted to join in on our trip. Her first words were, "You gotta be kidding, camping in the mountains in a tent, no electricity, no heater, and bears."

After a few days of thought and talking with her family she called me back and said, "Let's go camping."

And, camping we went! The vacation was refreshing and needed. It put peace back in my heart gave me a new perspective on my job search, and a new story to tell about friends helping friends through trouble.

Finally, two weeks before school started, I accepted a position teaching in the field of special education in the public school system. The personnel director at my new school placed me on an emergency certification plan for two years. This allowed me the opportunity to teach in special education. This was a new teaching field for me so additional certification and college classes would be necessary to earn my permanent certification. I was grateful for the opportunity and was more than willing to continue my studies. So I drove to Sam Houston State University, a hundred mile round trip, two nights a week to attend classes because some of the required courses were not offered locally. During the summer months, the courses I needed were offered at Texas A&M and it was a welcome relief not to have to drive so far.

God certainly picked me up and put me on a new path and I was simply following His footsteps. I did ask God to make his footsteps a little closer together as I was getting older and could not walk as fast. I was thankful for the opportunity and jokingly said to the good Lord, "Please, may I never have to go back to school again."

My new job involved teaching life skills and sharing practical information with a group of wonderful, special students. My students had a variety of disabilities and they were fun to work with. All of us were excited about learning new things each day. Classroom activities involved setting goals for the day, counting change, making craft items, developing a grocery list, going shopping, and experiencing a variety of community activities. We played games involving simple practical math and reading skills. Leisure time was spent around the table talking about careers and the skills needed to hold down a job. Time spent working with these students was quite rewarding as they

appreciated a smile, a hug, and the simple things in life. Their smiles in return warmed my heart.

I remember the first day I taught special education as I entered the classroom with my own "disability." I walked in with the aid of a cane and a brace supporting my broken left ankle. One of my students asked me, "Why do you use a cane and walk with a limp?" I replied back, "How about if I tell the story to the whole class?" The students gathered around the table and listened intensely to what I had to say. "There is always a story explaining why things are like they are, and this is one of my best stories to tell."

"It all started during the summer before I met each one of you." The students giggled and laughed as I pointed to each one of them. "Several friends and I went on a seven-day camping trip in the Wind River area of Dubois, Wyoming. We were driven twenty-five miles from town and dropped off on a ridge in the mountains. What a view we had as we looked at God's panorama of beautiful creation! Mountains of granite and limestone rock provided a rustic contrast to the blue and white sky reflected in the lakes and streams. Footprints of animals could be seen in the unmelted blanket of snow. Standing there we could see bald eagles, falcons, and hawks as they caught a ride on the gentle wind. In the distance was the glacier-carved valley that became home to one of the many trout-filled lakes in the area. At this point in our camping trip, we were unaware of how bitterly cold the nights were and how time was spent listening to the sounds of the wild. We were yet to enjoy the howls and crying of the coyotes and the wolves as they communicated with one another. This was life in the Wind River Mountain Range as etched in my mind.

"After soaking up the view, we loaded our gear onto five pack goats and began a fifteen mile hike to the site of our base camp. I was keenly aware that we were walking in the same area where the Shoshone Indians once traveled and hunted. With each mile of our trek, I would think of others who had possibly traveled this same way. Mountain men, pioneers, miners, and gold prospectors had blazed

these trails on their own journeys. Respect for this rough country increased as I walked the same trail of those who were tougher than the mountain range itself. This left within me a sacred feeling, a lingering presence of those who had passed this way. Their silent footprints remain only through artifacts.

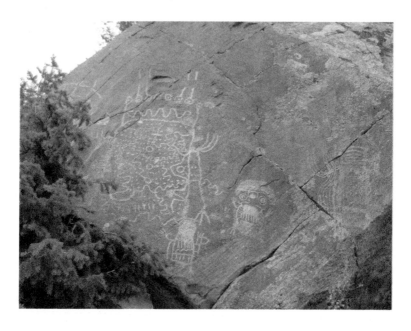

Silent Artifacts, Indian Petroglyphs in Wyoming
Sally J. Wulbrecht

"Indians and mountain dwellers may have walked those trails dressed in appropriate attire for the mountains. We, however, did not look like any who had gone before. Sweatshirts, t-shirts, sweaters, and jackets were layered on each of us. Blue jeans, boots, baseball caps, and Western hats completed our selections for hiking. Actually, we were a sight to see and looked as rugged as the country we were walking through. In addition to being loaded down with clothes, we also had an assortment of food, fly rods, tents, sleeping bags, and bear spray just in case we needed it. Part of our load was lightened because the goats were loaded down with our clothes, food, and tents. Every

once in a while one of the goats would run off with our packs, leaving clothes lying on the ground for miles. After the second runaway, the goats earned their new name of, 'Those crazy goats!' That loving phrase remained for the rest of the trip. Those crazy goats always came back, but we had to pick up and repack what was dropped. Something tells me we should have brought Wilber the mule, as he would have made our hiking much easier."

The students laughed and laughed as I brayed and continued my story.

"After walking for hours, we decided on a peaceful meadow nestled at the bottom of an outcrop of rocks. Tall, stately trees lined the pristine glacier- formed lake hidden deep in the wilderness, creating a place of serenity for our enjoyment. Freshwater trout were abundant in this lake so our plan was to fish daily for our evening meal. The area around the lake was plentiful with edible plants and berries and lush grass. Everything we needed was right there. We were happy and so were the goats. An outcrop of rocks formed the perfect spot for our kitchen. Food, hoisted up in the tree by a long rope, was protected from any possible encounter with a bear. Our tents were pitched closer to the creek, but far enough away to have protection from wild animals that traveled to the lake just after sunrise and late in the evenings when the sun was setting. We quickly learned to have a listening ear, always open for sounds of footprints much different than those heard in Texas.

"After our campsite and kitchen were completely set up, it was my turn to care for the goats. Casper, the friendly goat, and I were leading the other goats down to the creek so they could graze on the knee high lush grass around the bank. Casper was on a leash and the others were following him down the hill. We were just fine when all of a sudden Casper bolted away and ran off dragging his leash behind him. I lost my balance and down I went. The sound of my left ankle striking the top of the rock echoed throughout my body. That really hurt and I knew I was in serious trouble. While lying on the ground,

thoughts immediately started running through my mind. We were not prepared for a broken bone. We had no source of communication for help this far back in the mountains. Was my anklebone sticking out of my skin? Was I going to bleed to death right here and right now? So after those thoughts, I hollered for help, as the only things around me were 'those crazy goats'!"

Laughter erupted as some of the students said, "Help, help me goats."

"Just as I was hollering for help, Millie came walking down from the campsite to find out why I was lying on the ground by the creek. Together, we looked at my left ankle to see if there was any bleeding or a broken bone. A bright red pattern was rapidly forming around my left ankle. Swelling was taking hold and the pain was intensifying. There was no broken skin and no visible sign of a break. Leaving the goats to graze, I got up off the ground and slowly limped back up to camp. Millie followed behind with a bewildered look on her face as she was dealing with altitude sickness.

"My fellow campers met me with a quick pow-wow session so we could decide what to do. Together, we verbally mapped out how we could divide up to go get help. In this area of the wilderness, there were no roads and mechanized vehicles were not allowed. Jerry and Judy said they would walk back through the Wind River Range to get help, but it would take at least two or more days of hard walking. Sally and Millie would remain with me and help stabilize the swelling in my ankle. Help could be provided through the Forest Service in Dubois but Jerry and Judy would still have to walk back to town. The Forest Rangers could then come back on horseback or in a helicopter to provide help. Dusk was fast approaching and the cold wind was picking up. The dark cold night was setting in so we took a vote and agreed it was safer to stay together instead of dividing up. My new priority was to elevate my foot and rest.

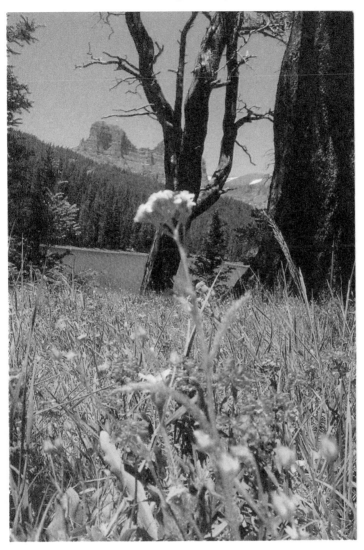

Peacefulness - Lake Wyoming
Sally J. Wulbrecht

"My friends gathered sticks and branches from around the lake to build a fire. It felt good to have some warm heat, as the night was bitterly cold and the air was frosty. Sally, Jerry, and Judy herded the goats and brought them back to base camp. Millie and I watched from the rocks and I will admit I rolled with laughter to see goats scatter in all directions. Gathering goats was like herding chickens,

they ran in all directions, but eventually they were rounded up and tethered by the campsite. Bedding down for the night was a welcome relief, and now the goal was to try and stay warm. Sunrise soon came and I was thankful to see that I could at least walk even if it was at a slow pace. Jerry carved a cane for me out of a straight branch that provided me with some stability when walking.

"During breakfast over an open campfire, we counted our pain medicine and found we had a total of twenty aspirin. I decided I would take three a day until they were gone. During the day, I would stand in the cool creek for hours and the rest of the time I wrapped my foot with socks and elevated my ankle. My friends were great and took turns hiking day trips from the base camp instead of continuing to the top of the mountain for fishing and hiking as we had originally planned. Someone was always with me for my protection. Actually, I felt confident until one day Millie and I saw a bear in the distance traveling toward the lake. She assured me there was nothing for 'her' to fear, because all she had to do was to outrun me in case the bear headed toward our campsite. I felt much better after those words knowing I was now going to be bear bait!

"Trout fishing was excellent, and sometimes we feasted on trout three times a day. One day, however, we cooked a type of wheat used to make pasta, called couscous, for lunch and it was just this side of nasty. So, Millie snuck our plates full of couscous and went to check on the goats. While there, she generously gave them our portion. And do you know, those crazy goats turned up their noses and walked away without one bite! Other great memories were formed as we sat around the campfire. We cooked, ate, sang cowboy songs, drank coffee, and simply enjoyed our time together.

"On the day we were to leave we packed up the goats with all of my gear, as my friends would not let me carry anything but water. Jerry took the lead walking at a slower pace than normal. Being in the middle of the group, I limped slowly down the mountainside, watching each step I took. The goats were in front of me so when

they ran off they would not run me over. After walking ten miles, we reached a low water stream and Jerry said a vehicle could travel to this distance. We stayed behind while Jerry walked another five miles to let Richard, the driver, know where to pick us up. Within three hours, the goats raised their heads as they heard the grinding gears of Richard's truck. We stood up and first took sight to see this old mud covered tan Chevrolet pickup creeping up through the mountain pass. Cheers to Richard and Jerry as they loaded up the goats and drove us all safely back to town.

"One more week was spent with my friends in Wyoming before catching my scheduled flight back to Texas. Upon my arrival in Texas, I went to an orthopedic specialist who took x-rays and showed me where my ankle was fractured. So this is why I use a cane and walk with a limp!"

The students clapped and laughed as I ended my story with a tap, tap, tap of my cane on the floor.

Chapter 14

Grace and Mercy

IN THE EVENINGS AFTER SCHOOL and during the summers I continued to take the required coursework for my certification. After two years, I completed the requirements and all that was left to take was the special education examination. Before taking the test, I spent time reviewing and studying with a group of other teachers preparing for the same examination. Early one Saturday morning, I took the examination and within six weeks I received passing results. I had earned an additional lifetime certification on my teaching certificate. The certification of special education allowed me the opportunity to stay in my current teaching position or to transfer to any specialty within the field of special education.

I was proud of my accomplishment and thankful to now have the time to look for another place to live. On Sunday afternoons after church, I would drive around the community and surrounding areas to look for ranch property to rent. I was unsuccessful in finding a place that was suitable. Either the places were too small or were large ranches that I simply could not afford.

As I had done in the past, I sat down and made a list of financial expenses in regard to my budget on a monthly basis. I knew exactly the incoming salary and outgoing expenses and what was left over at the end of the month. My truck was almost paid off. When I found out the ranch might be going up for sale, I tried to pay a little extra each month on my truck payment. The interest was lower on the student loan than on the truck loan, so reducing the truck note would save me more money in the long run. I had a four thousand dollar

balance on my student loan and it was slowly being paid off month by month. According to my calculations, within about four years I would be out of debt.

As I continued my Sunday afternoon searches I found a house on four acres. The location was safe and close to town. I stood next to the for sale sign that was posted at the front gate and said, "This is perfect." I was not able to look inside the house but from the road it looked great to me. As the week went on I would drive back to this same place and look. One day the gate was open and I drove down the driveway and peeked into the house. Sitting amongst huge oak trees was a three bedroom brick house with a large living room and a fireplace. The kitchen was set in beautiful ceramic tile work. A private water well was conveniently located in the backyard. I was excited to see that the barn was in workable condition for my horses. The place was perfect for me! Fences would have to be put up but that was a task I could do myself. The big question was how would I be able to afford to buy my own place? As I left the property, I simply asked the good Lord to provide if this property was His will.

Continuing on my journey to find a place to live, the "perfect place" was all I could find. I thought about how I could afford to purchase this property and the idea came to me if I had a roommate I could cover some expenses with the extra money. I was a little apprehensive at first about sharing my house, because I really enjoyed my personal space and quietness. Maybe it brought back memories of the Hamilton's one bathroom foster home where I shared a small room with two other girls. But the more I thought about owning my own property, the more excited I got about having a roommate. I knew of a friend that would be willing to rent a room. After all, a roommate could help with some chores. To remove all fear, I asked the Lord to stop me from buying this house if it was not the right choice for me.

The next step was to apply for a loan at the bank. I completed the application and visited with a loan officer. The loan was approved and to my complete amazement, my student loan had been paid off

three weeks before I saw the loan officer. I was shocked, completely speechless. This unexpected gift from my parents allowed me the opportunity to purchase my own homestead. They had no idea I needed to find a new place to live. I had no idea that they would ever consider paying off my last student loan. When I left the bank, I stopped in the walkway, stood under the American flag and thanked the good Lord for His grace and mercy.

It took awhile to move but the "perfect place" was mine and I had a roommate or two on occasion. I was happy building fences myself and redoing the barn. My three horses were right outside the kitchen window so I could keep a close eye on them. During the winter months, sitting by the fireplace, drinking coffee, and reading my Bible was prime time for me. The peace of the Lord was all over my property and set deep inside of me. Little did I know that through the years the surrounding property would come up for sale and my four acres would expand to twelve. Little did I know that by paying extra each month the entire property would be paid off in ten years and I would be free of debt. God is good and in all things God is good.

My house was located fifteen minutes from the school campus where I worked, which was a blessing all in itself. After school, several of my colleagues would meet one evening a month just to visit over dinner. Quite often, I was invited to join them. As we got to know each other better we discovered a common interest—horses. Mrs. Ellen was one of my colleagues who worked with students with visual impairments. When she was not teaching, she worked on her family ranch raising cattle, growing hay, and riding horses. Over time and lots of horse discussion, Ellen and I began to ride horses together. Her ranch, established in 1865, was covered with beautiful oak trees, ponds, lakes, rolling hills, and flat land. Together, as friends, we herded cattle from one pasture to another, drove the old truck through the pastures to throw out hay for the heifers, or sat on the tailgate of the truck and fished in the big lake. Many times we simply sat on the swings that hung from the front porch of the old ranch house, talking and

laughing. The wooden swings were as creaky as the wooded planks that covered the porch.

Ellen and I were riding partners and enjoyed riding from one end of the ranch to the other. Ellen always rode her roan mare, Dixie. I had my two older horses, Cloud and Chief, and my younger gelding Zandy to ride. I would trade horses from time to time but my true ranch horse was Zandy. The gentle horse training methods had paid off and Zandy had become a solid well broke horse. Instead of trailering him back and forth from my house, Zandy often just stayed on the ranch and grazed with the other horses in the pasture until I came out to ride the next day. He thought the Diamond E Ranch was his home away from home.

One evening after we finished our ride, Ellen's friend Janet arrived at the ranch just to visit. We all sat on the porch talking. The conversation soon turned to education and a high school dropout recovery program in Janet's school district where she served as an assistant principal. This was a brand new program and they needed a teacher to set up and oversee the programming. Janet explained to us that many of these students came from tough family situations and needed guidance to stay in school. Some were on their own and working full time without a lot of personal vision for the future.

Knowing the importance of a good education and overcoming struggles, I knew I could benefit these students. Simply out of curiosity, I completed an application and interviewed for the job. Little did I know, Janet had already recommended me to help establish their new program.

Within two hours, I was offered the position, provided I could get a release from my current district and teaching position. I immediately contacted my current director in human resources and said, "I know that school starts in one week but I have an opportunity to start a dropout recovery program in another district. Would you consider releasing me from my contract?"

The director said, "If your principal gives you a release, then our school district will release you from your contract."

I jumped in my truck and drove to talk with my principal face to face. He said, looking at his list of teachers and assignments, "Terry, I don't see your name on my roster for the upcoming school year so you're not creating an open spot on my campus. I will release you."

I then got back in my truck and drove to the other school district to talk to their human resource director. I told that director, "I am excited and honored to work in your school district and to help students achieve their education." We discussed being released from one contract and the time frame for providing me with a new contract. Together, the two directors made arrangements for my release and hiring within a one-week period.

The new job was exciting. Students who attended this program had difficulties in school and many with life in general. It was easy for me to understand where they were coming from and I marveled at God for placing me in this new position. I worked with one additional teacher, one counselor, and two administrators in a nontraditional educational environment. As staff, we selected a curriculum that allowed each student to master lesson upon lesson on an individual basis. Each course provided specific learning objectives that met or exceeded the highest educational standards. The design of the lessons or modules contained all the needed information so each student could read the material, answer the questions, take a practice test, and complete the final examination at their own pace. If a student needed help, my colleagues and I were available to help them.

I admired these students as I saw in each one a hidden desire to complete their education. Some of these students may have made poor choices, associated with the wrong people, or simply felt they could not achieve their education, but deep down inside there was a desire to better their lives. I passed on the words that were once told to me, "Hard work is a small price to pay for the rewards of a good

education. An education is a stepping-stone to making your life better. May you find the courage to make your life, the journey that is set deep within, the best it can be."

School hours were from seven-thirty in the morning until five in the evening. Sometimes, I would open up the building from seven to nine at night for the students who were working during the day. As students mastered their course work and earned credits, the feeling of success motivated these students to work harder to achieve their diploma. The first of many graduation ceremonies on a semester basis were exciting and full of cheers as a group of at-risk, potential dropout students were handed their first key to success, a high school diploma. Administrators, board members, and parents stood in the audience and cheered for the accomplishment.

One of the administrators pulled me aside after graduation and asked if I would help start a new disciplinary program for students in the district. My reply was, "I am honored that you would ask me to start another program for the district. May I take a week to consider the offer?" I explained that I had just accepted a freelance writing position to develop some science curriculum for the same company that supplied teaching material for our dropout recovery program. I wanted some time to think and pray about starting another a program along with fulfilling my commitment to write curriculum material.

After a week of prayer I felt the calling to start the alternative discipline program. I also knew I had limited time to produce the curriculum material. In order to complete the curriculum material within a four-month period of time I contacted Millie to help me. Instead of saying, "You gotta be kidding," she eagerly agreed and we worked weekday evenings at her home, sitting on the back porch writing and drinking coffee. Working outdoors under a huge oak tree with a twinkle light setting and an electric heater was perfect for the long evening hours. We worked hard to complete the curriculum on time right before the Christmas holidays. The material was designed to meet the highest educational standards according to Texas

Essential Knowledge and Skills, and the Texas College and Career Readiness standards. The completed material would be used across the United States in both civilian and military school programs where the learning was individualized and self-paced.

During the weekdays, I worked on setting up the alternative program for students who had committed an expellable offense. The goal was to keep these students in school. A dress code was established and daily evaluations for feedback were presented to the superintendent for approval. Once the program was approved, the material was put together in a student handbook and the doors were open for attendance.

A lot of hard work was done before the end of the first school semester. The accomplishments were successful, the job was done, and the Christmas break was welcomed. I was looking forward to riding my horses in the evenings with my friends and getting back to having a good nine hours of sleep and keeping life simple. Christmas day was just around the corner.

Some things never change, and this was reinforced to me when I went to my parents' home for Christmas. I arrived early in the morning the day before Christmas. After unloading my suitcase, I helped to prepare some of the meal for Christmas morning. There were many outdoor chores that needed to be done such as raking the leaves away from the patio, pulling up weeds in the rose garden, and setting out a few decorations in the front yard. After a long day of doing chores, I was tired, so I went to bed early.

Christmas morning started with a cup of strong hot coffee with a touch of chicory just like my grandmother used to make. After exchanging presents with my parents and eating our meal, I helped to un-decorate the tree and put the balls, tinsel, and lights away on the storage shelves in the garage.

Preparing to go back to my home, I picked up an empty box from the garage. I walked back into the house to ask my father if I could have the box.

My father was sitting on the couch and I remember his exact words. "Why did you take my box? I need it. You are so stupid."

I turned and faced him and said, "I will put your box back in the garage." Gritting my teeth and looking him square in the face, I said, "Don't ever call me stupid again."

Waiting for an explosion, I continued. "I roped and tied down the rejection, negativity, harshness, and criticism that has been hurled at me. I moved forward with my life, my dreams, and my goals. I had a vision to be better. I kept my focus. I did not allow circumstances to throw my dreams and hopes to the wind. I may have traveled the journey a little slower because of dyslexia; but I remained focused and steadfast until I earned my two college degrees. I am proud of my accomplishments and who I am. I didn't better myself by being stupid or unmotivated."

Still looking him straight in the eyes, I went on to say, "Oliver told me while he was in college that you sent him five hundred dollars every month. There were times when all I could afford to eat were beans and rice. But I didn't even let that stop me as I continued to work hard one step at a time, moving forward toward my goals, and the calling in my heart."

The whole time my father just looked at me as if my words fell on deaf ears. My father chose to harbor anger and it was obvious that my words fell on a cold and unrepentant heart.

As quickly as possible, I gathered up my dogs and my clothes, and left. With a heavy and troubled heart, I prayed as I drove home. I felt the Lord urging me to visit my parents again the next weekend. I responded with, "Lord, I haven't even gotten home and you want me to drive back in five days to visit." With tears in my eyes, I said, "My

heavenly Father, I am tired of being degraded and talked down to. My earthly father thinks my first, middle, and last name is 'stupid'."

Out of obedience to the Lord, I drove back the next Saturday. The visit went smoothly and time passed quickly as I helped with more chores around the house. I will always be thankful that God urged me to go back home and I'm also thankful that I listened to him. Being loved and belonging to this family was important to me as a young child. As I grew older, belonging to this family would never have been my first choice but it was a situation I could not change.

I often wondered if I had been placed with a ranching family up in the mountains of Wyoming how my life would have turned out. I could easily imagine myself as a child riding horses alongside my father and mother through the majestic mountainside of the Tetons. I could picture in my mind the snow melting from high on the mountainside and flowing into a lake, creating a sparkle from the rising sun on the surface of the water. Together as a family, we would watch the elk and moose scatter from the tall willow bush as we rode through the edge of the water. This was the life I pictured in my mind.

In reality, I can't live on "what if things had been different." I have to deal with where I am now and use the experiences of the past to make my life better. There is no control over situations that occurred in the past, to whom I was born, or who my siblings are.

However, I do have control as to how I act and react to those situations. I can honestly say there is peace in my heart and forgiveness for the way I was treated. Most of all, I knew that I was God's child and He protected me and filled in the gap with people who showed me love and kindness. Their acts of kindness were paid forward years and years ago. It was love and kindness that gave me the courage to survive and to keep my heart pure. It is through love and kindness that I choose to live the rest of my life.

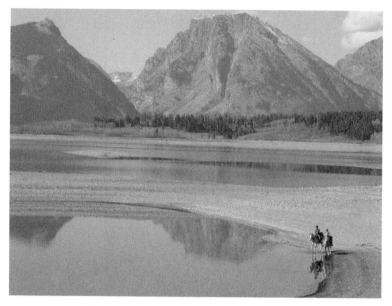

Hermitage Point - Grand Teton National Park, Wyoming
Sally J. Wulbrecht

While driving home I thought to myself, "What makes some people so willing to help others while others simply just don't care? What makes a heart soft and willing to lend a helping hand to others?" A pure heart brings healing and peace. Love, joy, and peace can change a life, a neighborhood, and a community. Perhaps it all starts will the willingness to share kindness—the gift of giving, helping a stranger, gathering together to support a child, standing strong after a disaster. Within the reach of our arms is a life that we can help make a little better. I am proof that the simplest act of kindness can change a life.

As I turned into my driveway, I thanked God for His love, protection, and a safe trip back home, as we really never know what the next moment holds.

"Good words do not last long unless they amount to something."

Nez Perce

Chapter 15

Purpose in Life

EIGHT DAYS LATER, I received a phone call from a family member telling me that my father had dropped dead of a massive heart attack. This time when I returned to my parents' home, it was to help make funeral arrangements. The reality of old age and death hit me hard that day.

The graveside ceremony was simple with bagpipes playing "Amazing Grace" in the background at the end of the service. I stood next to Miss Lili as the music slowly faded into silence. The American flag was removed from the casket, folded, and handed to Oliver.

As the family walked away, I got the chance to thank Miss Lili for planting positive words in my life. She said to me, "Terry, never forget me. I will always love you, and I am so proud of you. Never forget me."

I replied back to Miss Lili saying, "Your kindness, and gentle encouraging words made a huge difference in my life. You helped me to find my purpose in life, my calling to teach, and to help animals. I am a better person because of you. Thank you for loving me." I hugged Miss Lili and reminded her of what she said to me when I was young: "I remember you telling me, 'With God's help you can be anything you want to be.' I learned from you to talk with God and trust Him for everything. I remember you telling me that God loved me, He created me, and that I was not a mistake."

With tears in my eyes, I leaned down and whispered in her ear, "Thank you for loving me, I will never forget you." I knew that Miss Lili truly cared about me and my relationship with the Lord. She encouraged me to follow my dreams and to live the journey that God set in my heart. Her act of love kindled the desire to pass on kindness and encouragement to others.

The strength of Miss Lili's younger years had unraveled, leaving her frail and fragile. It was painful to see her health dwindle. After taking a few small steps with the use of a walker, she pointed to her husband's headstone that was next to my grandmother's grave. She said, "I will be next to him someday."

Never did I think the person who said, "Terry, never forget me," would have no memory of who I was within a few short months of our visit, but Miss Lili's mind was fading away like a boat slowly drifting out to sea.

After the funeral, I realized I needed to slow down and not work so hard. I had been burning the candle at both ends for years. Although the candle was still burning, it was getting shorter and shorter. I thought about the frailty of life and how Fifi must have felt as her Mother's mind faded away day by day. Fifi was now caring for her father by herself.

I asked the question out loud, "Who would take care of Fifi in her elderly years?" She deserved the same kind of care she gave her parents. So I made myself a promise. I would help Fifi and her father any way I could. Deep inside my being, my soul, it was my desire to care for my friends because my friends were my true family.

I really missed Fifi and the fun we had saddling up and going horseback riding. The times my friend and I rode horses together were still etched strongly in my memory. I laughed out loud, thinking of how this cowgirl tough, petite lady climbed up on a ladder to get on my sixteen-hand gelding. How we would look each other square in

the face before taking the first step would never be forgotten. Perhaps a horseback ride was just what I needed.

The first week back at work was tough as I was absolutely worn out. I needed my horseback ride and a day off just to be with my horses so I called in sick, a wellness day, for myself. I also called Ellen to let her know I was back home and to thank her for keeping and feeding Zandy for me. During our talk she told me about a grant being offered to certified teachers, on a graduate level, who were interested in teaching the visually impaired. The grant was initially developed because there was a shortage of teachers and orientation and mobility specialists in the teaching field of visual impairments.

I knew that Ellen was a teacher of the visually impaired and how she enjoyed working with her vision students. She would travel from campus to campus working with individual students and classroom teachers. She agreed with me when I said, "This is a job I could grow old with and continue to work in my current district." Ellen joined me in praying about this opportunity.

The more I thought about it, changing positions, although a little unexplainable, was exciting to me. I asked the Lord to guide me or close the door if this was a change that was not good for me. After receiving the paperwork, I applied for the grant that was offered through the State of Texas. God absolutely answered my prayer for guidance and the door blew wide open and fell off the hinges. My application was approved and I was on my way to working with visually impaired students in my school district.

Once again, I was placed on an emergency certification until I passed an examination for my new field of teaching. The state at the time required the passing of an examination but the grant required me to take a required amount of classwork. After registering for the examination, I was sent a study guide that I reviewed over and over. I underlined each topic for my independent research so I could gain

knowledge in the field of visual impairment. I developed an outline of topic information and reviewed the material daily.

I signed up to take the examination on a Saturday, four weeks after receiving my study guide. To my amazement, I passed the test. Because I wanted to be the best teacher for my students, I knew I needed further knowledge and training. My college career was not over and I once again attended classes. I was excited to call Fifi and tell her, "I have a new J-O-B." After explaining the necessary coursework, she responded by saying, "When are you going to stop attending college?" Together we laughed.

I was at peace about the change in careers because I knew I was following God's will. I was not real excited about going back to school but that's what I needed to do to accomplish the task at hand. After all, I handed the reins over to the good Lord for his guidance and I needed to follow through with His plan. The educational training was for two six-week summer sessions in Austin, and every Saturday at the educational service center in Houston. Both locations were approximately two hours from my house, depending on the traffic. Training would last until the vision and orientation and mobility coursework was completed, which would take approximately two years.

My elderly neighbor insisted on feeding my animals while I was in Austin. Cloud and Chief had plenty of free choice hay set out for them so all they needed was some grain on Tuesdays and Thursdays. Zandy stayed at Ellen's ranch, which made feeding the horses at home simple. My three Border Collies were fed once a day while I was gone to make it easier for my neighbor. Her kindness helped to make my training possible. I would leave my house by five o'clock, drive two and a half hours every Monday morning in order to be sitting in class by eight. I allowed extra time for the traffic driving into Austin.

The days were long and the intense training took total concentration and focus. For the first summer session, the grant covered an apartment for my stay in Austin. Several of my new colleagues in the program were staying in the same complex, which made it convenient for studying together.

To help keep my mind fresh, I chose to come home on Wednesday evenings to be with my animals before driving back on Thursday mornings. This gave me the chance to check on my neighbor and to give her a break from doing the feeding for me. It also gave me the chance to ride Zandy for a few minutes on Wednesday evenings. I would leave early Thursday morning for class and return home again on Friday evenings. The weekends were filled with quietness, rest, and appreciation for a peaceful country home environment.

The first part of my training was to learn Braille and the foundations of visual impairments during the six-week summer session. Once I figured out that Braille was just an arrangement of dots in a specific pattern for each individual letter or word, I knew I could master the task. I visually thought of the Braille pattern as if it was a single die, showing six dots on its face. On the left, the top dot was represented by the number one, the middle dot was number two, and the bottom was number three. On the right, the top was number four, middle number was five and the bottom represented the number six.

For the Braille alphabet dot one is A, dot one and two is B, dot one and four is C, and so on until you get to Z which is dot one, three, five, and six. Just like I did in college, I wrote the patterns on paper and studied them over and over until I had them memorized. My study of Braille was by sight and not touch.

I studied the Braille patterns so intensely that I thought the dots were going to line up, run, and jump away off the paper! In Braille, there are patterns not only for the alphabet but also for punctuation, shortened words, and mathematical numbers and symbols.

The study of foundations of visual impairments was interesting and less intense than Braille. Foundations involved the history of programs, which serve the visually impaired, along with specific eye diseases. Together, the coursework was extremely rigorous and challenging as it is taught in a condensed fashion, but the training was necessary for my new career. I survived six weeks of training and was ready to stay at home for the rest of the summer until school started in August. My next set of classes, academic methods and orientation and mobility seminars, including practicum time, would start in January in Houston. The timing was perfect, so I could devote my attention to the new job.

Having this new teaching position rejuvenated me. Like a strong twisting wind, God picked me up from one direction of travel and placed me in a new direction. This new job brought much happiness because of my supervisor, a lady who had my utmost respect. She was a self-made educator who had overcome tremendous obstacles in order to reach her level of success. Dr. Morgan was an educator who cared deeply for all students and for the staff who worked for her. She made each staff member feel they belonged and were part of a team. Her words were always positive and they carried a powerful meaning so that each person felt valued.

Dr. Morgan was a woman of her word who held each of us accountable to a high standard of work ethics. It was the same work ethic that she held for herself. Each time she mediated meetings, I would watch and learn how she solved problems. Dr. Morgan would listen to each person unconditionally and would treat each person with equal respect and kindness. She listened and gathered the facts before solving the problem. She would complement the positive and correct the negative. I saw the end result of treating each other with honor, honest communication, and respect. This positive approach made me want to please my boss and to give the job my very best effort.

Chapter 16

Triumph and Trials

FOUR MONTHS AFTER BEGINNING this perfect job, a catastrophe came along. It was a time of triumph and trials, tears and pain, along with forgiveness and humility. The Lord knew that I needed this new teaching position and Dr. Morgan to help me get through a tough situation. If I had remained in the previous position, the outcome for recovering and for employment would have been much different. My inability to regain my strength would have changed the course of my life forever. My faith in God and my physical being was stretched beyond my imagination.

I remember that dreadful December day as if it were yesterday. As I left my home on a Monday morning for an eight o'clock meeting, after backing down my gravel driveway, I put my truck in park, left the engine running, and stepped out of my truck to close the front entrance gate. After closing and locking the gate, I walked back towards the driver's side of my Chevrolet three-quarter-ton truck. The sound of my neighbor's vehicle grew closer and closer as he continued to veer off course at a speed over 60 mph.

Little did I know that I would soon be in critical danger. Suddenly, the morning went black as I lay face up in the gravel road surrounded by pieces of metal, gasoline, and the fumes coming from the totaled vehicles. My limp body was facing the morning glow of the rising sun. Peter, the teenager who ran his car into my truck, was not able to wake me so he left the scene of the accident and ran one-fourth of a mile back to his house.

Neighbors later informed me that they drove by and saw me lying in the ditch and they thought I was dead. No one stopped to help. All I remember is the Spirit of the Lord saying in an ever-so-soft presence, "*That's my child. Get up.*"

When I came to, I was sitting in the driver's seat, leaning over the steering wheel of my vehicle, traumatized and nauseated. The door to my truck was open. The driver's side window was down, and the cool air was chilling me. My engine had been turned off, and I was all alone. There was no one around.

At some point in time, I stepped out of my truck and noticed there was a car behind me. It looked like a rippled accordion. Smoke was smoldering from the engine and gas was pouring on the ground. In a daze, I walked back to my truck to sit down and use my cell phone to call Millie. When she answered I said, "Help me. I have had a wreck," and then my phone went dead.

Sinking into the seat of the truck, I cried out, "Lord, I need your help." Within a few minutes of my cry, Peter's mother appeared and asked if she could call a friend for me. Searching through my memory, focusing was difficult and the numbers were foggy but slowly I recalled my friend's phone number.

The phone was handed to me and Millie answered and said, "Where are you?"

I quietly said, "At home, I need your help." I handed the phone back to Peter's mother.

She then turned and walked away to console her son who stood by his totaled vehicle.

The pain in my body intensified as I sat in my truck, waiting for help.

Off in the distance, somewhere over the horizon, the sounds of sirens began to fill the morning breeze. I saw another neighbor who lived a few houses away slowly driving toward my vehicle. I got out of my

truck and stood by my vehicle because I thought this neighbor would help me.

This neighbor loudly stated, "Not surprised this happened, Peter always drives too fast down our dead-end street." I asked him to repeat that statement to the sheriff when he arrived. The neighbor said, "Oh no, we don't want to get involved," and drove away. Still standing alone, chilled by the cool morning air, I waited for help.

Sounds from the ambulance, fire truck, and the county's law enforcement vehicles intensified and throbbed through my head as the pain in my body increased. Upon arriving, the emergency medical technicians got out of their ambulance and walked over to me. They noticed I was mobile and cognizant as I stood next to my truck. Quickly assessing my condition, they handed me an ice pack and said, "You are welcome to go to the hospital with us or you can have a friend drive you to the hospital. We are leaving now and if you do not intend to go to the hospital in the ambulance, please sign here." Handing me a pen, I signed the form. They turned and walked away, leaving me holding an ice pack on the right side of my head. As they turned away, I sat back down on the front seat of my truck. The whole situation was making me nauseated.

While trying to process the situation, I noticed the D.P.S. Officer was talking with Peter and his parents. After recklessly plowing into my vehicle that was parked on my driveway, Peter was now shamelessly telling the officer that my truck was blocking the road and he ran into me.

Quickly, assessing the accident, the officer clearly clarified to the Peter that, "The woman you hit was legally parked just like I am legally parked." He then explained that, "Even though the driver's windshield was fogged over, the real issue was that the driver was not paying attention, was driving on the wrong side of the road, and even ran off the road in order to hit the parked truck. The driver made a

very poor choice and that action brought pain and suffering to an innocent person. It is a miracle that person was not killed."

Words were swirling in the air and through my mind. I felt I was sinking into helplessness. Within minutes Millie arrived at the scene. She walked up to the officer and stated who she was and why she was here. Together they assessed where my vehicle was struck, where I was standing, and how my vehicle in turn hit me. After the wrecker moved Peter's totaled vehicle, another wrecker then prepared to move my wrecked truck. Millie and the wrecker driver unloaded the contents of my truck into a wheelbarrow and pushed it down the driveway to my garage. About one hour had passed since my morning's routine exploded and I was now sitting in Millie's car waiting to go to the emergency room. I at least felt safe because my friend was there to help me.

Driving a bit over the speed limit, we reached the entrance to the hospital emergency room. Even though dazed, I was able to walk through the double doors to the front desk while Millie was parking her car. I was fortunate because the intake nurse took one look at my left leg and immediately took me back for treatment.

After explaining my accident to the emergency room nurse, he looked at my left leg and looked back at me while saying, "You walked into the hospital?"

I said, "Yes sir, I did."

The rest of that day was spent in the hospital before I was released to go home. X-rays, CT scans, and an MRI revealed my injuries. In addition to a concussion, my back was fractured, several ribs were cracked, teeth were broken, and both of my knees, shoulders, and ankles were bruised, swollen, and inflamed. My left leg was red, swollen, and oozing blood.

The emergency room doctor looked at my wounded leg that looked like it had been mangled by a piece of metal. Shaking his head, he

looked me square in the eye and said, "Terry, you are most fortunate to have your left leg still attached."

I replied back to him, "I was left for dead in the bar ditch in front of my house. I was lifeless and God spoke to me and said, '*That's my child. Get up.*' When I woke up I was leaning over the steering wheel in the front seat of my truck trying to figure out what had happened."

This terrible accident changed everything, and now I was faced with the most difficult challenges of my life. I knew that I would have to maintain a balance between my job, continuing education to keep my job, and physical therapy in order to recover. At this time, I was not even thinking of the number of surgeries that were going to be needed to restore my health.

I missed one week of work before the two-week period of the Christmas break. The day after my accident, I made a doctor's appointment on the first available opening, which was a week after the accident. There were phone calls from the insurance adjusters almost daily. My insurance adjuster drove from Houston to my home to get a complete statement in person and to take pictures of my injuries and truck. Although I was sore and tired, I complied with the insurance process with my insurance company and with Peter's company.

I read my Bible daily and wrote out my own version of the 23rd Psalm. I meditated on it daily for the next two weeks. "The Lord is my shepherd and I shall not want. I pray for safe pastures and protection, the strength to restore my health, and to rest in God's will. I will trust the Lord to provide my needs day by day. The Lord will take care of me in the midst of a stormy day. He will walk with me through the valley so low to the top of the highest hill, through whatever is ahead of me. The Lord will provide me with the strength and determination to face tomorrow and the courage to travel the journey set before me. Please hold my hand dear Lord and help me

to live in the center of Your will. You're all I have Lord. I need You Lord and I want You to be proud of me."

I imagined the Lord pouring warm oil with an aroma of rosemary all over my head. In my mind, I could feel the warmth of the oil entering my body, soothing my injured muscles and bones. The words "stop and look for goodness and mercy shall follow you all the days of your life" took on a whole new meaning. I sat quietly, listening for the still small voice of the Lord who provides abundant peace and protection to His children.

One week after the accident, I called Fifi to tell her what had happened.

She said, "Ter, are you okay? I can't believe this happened in your quiet, peaceful neighborhood." Understanding the stress of caretaking, Fifi, encouraged me to take life just one day at a time, oftentimes just moment by moment. "Slowing down and listening to your body, not overdoing yourself, will help you to dig way down deep inside and gather up the courage to move forward and recover."

This advice from my dear friend proved to be invaluable. Pain intensified with each day, and I found it hard to sleep. I wore a TENS (Transcutaneous Electrical Nerve Stimulation) Unit that helped to stimulate my muscles, lessen the pain, and allow me to get through the day and night. My right shoulder suffered the most damage from the initial blow, resulting in a frozen shoulder. The physical therapist that worked on me three times a week was a retired Marine on the other side of tough. I remember her pulling and pushing on my shoulder until I broke out in tears. The pain was intense and increased after every session.

With the *utmost compassion* she would look at me and bark, "Quit crying and breathe deeply until I get finished!"

This overly aggressive stretching increased the inflammation and decreased the range of motion. The day came when the right

shoulder was radiating in pain, pulsating from my shoulder down to my fingers because the physical therapist was making the situation worse. No longer could I stand the pushing and pulling of my shoulder that was frozen solid like a block of ice. So I made the decision to seek another physical therapist that specialized in shoulder injuries. Mr. Jacob Cleere was like a breath of fresh air. He worked with me in a much kinder way to relieve some of the pain due to scar tissue and adhesions in my right shoulder.

At work, Dr. Morgan was extremely supportive of my need for physical therapy, and she told me, "Terry, your physical therapy must come first. You will get your job done but your recovery must be your primary concern."

After a period of time, Mr. Cleere recommended an orthopedic specialist and explained that there was a surgical procedure for removing the impingement, adhesions, and scar tissue. Mr. Cleere knew surgery was necessary to return my shoulder to full range of motion. He and I talked about a time frame for the procedure, physical therapy, and for recovery. I explained to Mr. Cleere why I was attending training and classes on Saturdays in Houston. He understood my determination to push through the pain and to fulfill my commitment.

Saturday hours were from nine to four, which was good as it allowed me to drive home before dark. The courses were interesting and the other teachers in attendance were working on achieving the same goal, a teaching certificate in vision and a certification as an orientation and mobility specialist. I sat in a comfortable chair next to a table so I could use my laptop computer to type in notes. I used a heating pad to keep my shoulder warm, thus reducing the pain. During the lunch break, I would rest and eat in the room. While by myself, I verbally read my notes into a tape recorder; highlighted important facts, and developed study questions verbally. This helped me to utilize my time wisely and study while I drove back and forth to class. I listened to the tapes over and over until I learned the material.

During the week, I focused on the needs of my students. I was traveling from campus to campus, consulting with teachers and meeting with several students on a daily basis. I arranged my student and campus visits so I could get in an hour of physical therapy three times a week during my lunchtime. As I drove from campus to campus, I replayed the notes I recorded in class. This helped to keep my mind fresh on my studies and free up some time at home for chores. By the end of the day, I was exhausted so I made sure I got my needed nine hours of sleep every night. This schedule continued for four months until the end of the school year in May.

There was one more summer session to complete before I could even consider having my right shoulder repaired. This session focused on cane skills, structure and function of the visual system, along with a variety of multi-impairments that often affected the visually impaired child. Teaching the deaf-blind was a major topic for discussion. My neighbor was kind enough to offer to feed my animals for me just like the summer before. My living arrangements for this session were in a college dorm on the campus of the University of Texas. I had a small room with an uncomfortable twin bed and an adjoining bathroom facility, which was shared with another teacher on the other side. The noise level vibrated from the first floor all the way to the top of the dormitory and back down again. Besides students who attend the University of Texas for the summer, the dormitory was filled with seventh and eighth grade students who were participating in basketball and soccer camps. Each morning, breakfast was served in a common area where we all gathered for a meal.

I was thankful to come home during the middle of the week, as I was way too old for dormitory life and living in such a close area with students who were away from home for the first time in their life. I had a countdown of six marked on my desk calendar, as I was anxious week by week to complete my last summer session.

After completing the summer course work, it was now time for surgery. I made arrangements to have my shoulder repaired the week

after I returned from my summer session. The procedure went well and I was relieved to have it done and over with. The orthopedic surgeon, Dr. Holt, did an excellent job in removing adhesions, scar tissue, and in repairing a rotator cuff tear. While in surgery, Dr. Holt manipulated my frozen shoulder by stretching some of the tight tissues around the shoulder. This manipulation was helpful in increasing my range of motion. Two weeks after surgery, I continued with physical therapy three times a week and daily exercises to strengthen my muscles for the remainder of the summer.

Finally, after six months, the pain in my right shoulder began to decrease and I could start riding horses again on a regular basis. I rode Zandy bareback just to feel the movement of the horse. Cloud and Chief were now in their middle thirties so I considered them retired. I knew their lifespan was almost over, so Zandy was my best riding partner.

Since I could no longer stand on the ground to jump up on my horse I had a mounting block built especially for me. This wooden mounting block had four steps with a handrail and a flat platform at the top to stand on. This was the perfect answer to my physical situation. It was tall enough for me to stand on and swing my leg over the back of my horse. After grabbing some mane and sitting on Zandy's back, I would sit for a few minutes to let my muscles relax. Then Zandy would slowly walk around the arena until my pain level increased to the point where it was time for me to stop and dismount. Zandy developed the habit of walking back to the mounting block quite often, just in case I wanted off. He seemed to understand my pain level and was patient with me as I started out riding only five minutes at a time. He was given a carrot as a reward for walking slow, which was not normal for him.

After each ride I would write in my gratitude journal about my horses and how they brought so much happiness into my life. I made a big note in my journal, "As a gift to myself, someday, I will ride on

horseback through the mountains of Wyoming, the mountains that I love."

This promise to myself gave me more of a reason to ignore the pain and increase my riding time a few more minutes at a time.

Life progressed to a new normal as I learned to live daily with aches and pains. It seemed that I would barely get one body part repaired when another pain would pop up. The same procedure of therapy, exercises, and surgery was followed on my left shoulder five months after the repair of my right shoulder. The left shoulder procedure was scheduled on a Thursday during a time when I did not have to be in class on a Saturday. I needed a long weekend to recover from the anesthesia before going back to work on Monday. My right shoulder was strong enough to compensate for the weakness in the left shoulder so I was able to go to work right after surgery. I continued with physical therapy sessions and exercises for another twelve weeks.

My knees were next on the list for repair and once again Dr. Holt was my doctor of choice. The staff at the hospital knew me from the previous surgeries and would call me by my first name. Surgery after surgery, physical therapy after physical therapy, I was more aware of the need for God's helping hand than ever before.

I was grateful to have friends who were willing to pick me up at home and drive me to the hospital for surgery. Most of my friends were working fulltime so they would drop me off at the front entrance of the hospital and pick me up after surgery. It was a strange feeling to sit in the surgery waiting area of the hospital by myself until the intake nurse called my name. As I waited, I silently prayed for the people around me and mentally listed things I was thankful for. When my name was called, I entered the preparation area, signed all the necessary forms, then changed into a gown and laid down on the gurney. Once the IVs were in place and the monitors attached, I would ask for a warm blanket and rest until I was wheeled into the operating room. My wait time varied from thirty minutes to hours

depending on the progress of the surgical procedure before me. All in all, I was at peace because I knew that God would take care of me.

In the operating room, I vaguely remember doctors and nurses talking to me. The anesthesiologist would ask me to count to three and when I got to three, I drifted away. The recovery room was my next memory of waking up. I was fed a snack of apple juice and graham crackers before getting dressed to go home. When I was ready to leave, the nurse would call my friend to come pick me up and take me home. Oftentimes, it was not the same friend who dropped me off in the morning. At home, I remained quiet and still as I was there by myself. My chores were done early in the morning before surgery so I could rest when I got back home. My dogs would fall asleep on the floor by my bed as I rested. It was up to me to monitor my pain level, to be safe, and not to fall.

Fifi would call me in the evening after surgery to check on me and make sure I was okay. I remember several times when my veterinarian would call to see if I needed anything. My boss, Dr. Morgan, proved how much she valued me when she came to my house after the first surgery to deliver a single yellow rose. She, too, wanted to make sure I was okay. Elizabeth, the sister of one of my college friends, would call and check to see if I needed anything. When it came time to feed my horses, Millie told me to call her before I walked to the barn and to call her again when I got back in the house so she would know I was safe. Their acts of kindness were comforting, as I knew I was not alone.

I was most grateful when my friends Millie and Elizabeth were able to help me out when I had surgery on my left knee. Millie was the driver and Elizabeth was the caretaker for the weekend. Millie would come pick me up early in the morning and stay with me until I was wheeled down the hallway of the hospital's operating room. While we were waiting she would quote Bible verses and sing "Amazing Grace." This made the time go much faster. During surgery, she would go eat breakfast and then come back to the hospital and wait for the doctor

to talk with her about my surgical procedure. Later that evening, after work, Elizabeth drove from her home in Galveston just to care for me and feed my animals for the weekend.

Those acts of kindness were huge as they made me feel secure and safe. Without the connection to friends who truly cared, the pain and suffering from my accident would have intensified greatly. Words cannot express how much I appreciate my friends and their kindness. My friends proved once again that they were my true family.

It seemed like something always broke right around my surgery time. Elizabeth was at my house for the weekend taking care of me and feeding my animals after my left knee surgery. Early Saturday morning, both she and I noticed we had no water. Because my home is in a rural area, I had my own water private well that supplied water to the house and barn. Although the well suddenly quit pumping, I had enough water in the troughs for the horses for two days. I did not have enough water stored in the house for home use and for us to drink. Problem solving the day after surgery was a challenge, but I knew we needed water.

Using my crutches, I walked to the well house, opened the door, and was greeted with a horrible odor of burnt plastic and wire. Immediately, I saw the tail of a snake hanging from the motor unit and knew the motor was shorted out and would need to be replaced. After turning the electricity off, my friend Elizabeth drove me to town so I could purchase the necessary parts for the repair. I contacted a friend that worked for a local hardware store to see if he would come after work to rewire the system. He assured me that he would be there in two hours. He never showed up, so I called him again but he did not answer the phone. The saying, "You can count all your friends on one hand," is certainly true.

The late afternoon was about gone and it was starting to get dark outside. I said to Elizabeth, "I'll have to rewire the well motor myself so we can have water." After wrapping my left knee with a plastic

garbage bag, I used the crutches and walked back into the well house. Elizabeth carried a stool, a black marker, and a flathead screwdriver. I wore a red bandana around my face to filter the stench of burned wire and snake. Sitting down on the stool, I began to code the wires, marking them with my own system. It was simple: A to A, B to B, and C to C. Soon I had disconnected the wires, put in a new part, and reconnected wires, matching my codes together. When this was done, using my crutches, I stood up and flipped the electricity to the on position. Just as I had planned, ground water bubbled up to the tank and the water began to flow!

Elizabeth, who was watching from outside the well house, was pleasantly surprised at my rewiring technique. Grateful to have water, she shouted, "Hallelujah! Thank you, Lord!"

As time passed, it seemed like it was just one surgery after another. Millie was my designated driver when my left ankle was pinned and fused together. She picked me up the morning of surgery and waited with me until it was time for my actual procedure. She spoke to each of my doctors before surgery so she would know what to expect in terms of my pain level after surgery. Before surgery, the anesthesiologist explained to Millie and me about the pain pump and how he would use an ultrasound machine to locate the nerve. He said he would thread a catheter directly into the nerve, attach a small pump to the catheter, and place the pump in a fanny pack around my waist. The medication in the manual pump would produce some numbness in the ankle, thus reducing my pain level. He told me to be extremely cautious and not fall, as the medication could cause muscle weakness. He told Millie how to remove the catheter from my nerve after three days.

After saying to the doctor, "You gotta be kidding," I told Millie I could pull the catheter out myself.

Because I could not walk without the aid of crutches or a knee walker, Millie insisted on staying and caring for me for three days

after surgery. What an unselfish gift of friendship that was, as I had a hard time getting my pain level adjusted. Her assistance was invaluable in helping me to recover after such an intensive surgery.

The night before my ankle surgery the hot water heater stopped working. I could not cancel surgery and I did not have time to replace the heater before surgery. That same night, my school colleagues, Janice and Johnny, called to pray with me. After our prayer, I told them about the hot water heater. Immediately, Johnny offered to go to town, get a new water heater, and install it for me while I was in surgery. Johnny and Janice took care of the entire situation and made sure I had hot water when I got arrived back home.

I was grateful for the group of friends that God had sent into my life. I was blessed to have friends who would stop what they were doing to help take care of me. Without the aid of friends, old and new, I would have had a more difficult time getting through those years of surgeries. Good friends are priceless. Even the simplest act of kindness connects us together like a bond of steel. Kindness makes us feel special, compassion recharges life, and generosity can move a life forward. It is amazing how one life can recharge another life.

After my automobile accident, I needed to hire someone to help me unload horse feed and to stack hay. Five pounds of dog food was easy to handle, but a fifty-pound bag of horse feed was a bit of a problem. My friend, Ellen, had a part-time hired hand, Mr. Walton, who worked on her ranch. I contacted Mr. Walton to see if he had some time to help me until I got stronger.

He said, "I work full-time at the large animal clinic at A&M and part-time for Miss Ellen. But you're in need and I will make time to help you."

That was the beginning of an unusual, but solid friendship. We were quite different in our cultural background and in the tone of our skin. Mr. Walton had a 5th grade education but was full of common sense.

He was a man of integrity and relied on the Lord completely. Within a short amount of time, we became good friends.

Mr. Walton was a Godsend for me. He delivered hay. He took care of my horses. He helped me unload groceries. He took care of my fences and pastures. He mowed the yard and pasture. He made sure I was safe. My dogs thought Mr. Walton was absolutely wonderful and gave out a round of howls when they heard his truck rounding the corner towards my house. His old brown and white Chevrolet truck made a unique sound that my dogs always recognized. My three black and white Border Collies were often seen following Mr. Walton while he was doing my chores. My friend lived out the words, "We are our brother's keeper," and I grew to love him just like a brother. The good Lord could not have sent me a finer man to call my brother.

When Mr. Walton first started helping me out I talked to him about the accident and where it occurred. We would talk about the Lord and blessings more than the accident. But I still remember the time when my friend, Mr. Walton, said to me "Did Peter and his parents ask you for forgiveness?"

I said, "No."

My head sunk downward as I fought back the tears. I tried to explain the picture etched in my mind. It was like being trapped in a thunderstorm with lightening striking in all directions. Even though the bent metal, crumpled vehicles, and blood have been removed from the site of the accident the aftermath lingered in my body. With every move I never knew when the inflammation would send a charge of pain through my body just like a bolt of lightning. I had to deal with the reality that the pain and suffering from my internal injuries, broken ribs, fractured vertebrae, and torn muscles would forever change my life.

Looking at Mr. Walton, I said, "Peter and his family chose to continue on with their lives as if nothing ever happened. They

showed no compassion, no response to my suffering, and no desire to help me."

There was an opportunity on a daily basis for this family to stop and help. Oftentimes they would see me slowly walking to the barn as they continued to drive down the street.

I hurt with every breath of my being and what were simple tasks and routines became a challenge to complete. I struggled to take care of my animals and myself since I could only lift one pound at a time. Feeding each of my three horses five pounds of feed, twice a day, took a great deal of time. Although my energy level was low, I focused on what needed to be done.

I will never understand how someone could cause a near fatal accident, to a neighbor in fact, then just turn and walk away. If I had done that to someone else, I would have felt horrible. My first action would have been to ask for forgiveness and then to help them in any way I could.

Looking back at the ground, I said, "In my heart, I had to fight back anger because of the accident itself and the complete lack of compassion." Because of my early childhood experiences, I knew I could not allow anger to fester inside of me and destroy my desire to recover or to camouflage the values I believed in.

Forgiveness oftentimes is easier than forgetting. So, two weeks after the accident, I stood in the same area where I was left for dead and I asked the good Lord for forgiveness and a safe recovery. I walked away from the accident site with a greater understanding for the need for compassion and for loving one another.

After making eye contact with Mr. Walton I said, "Peter's father is a minister in a local church." Silence then filled the air for a few moments.

I then heard Mr. Walton say, "Seeing the needs of the peoples around us and doing something to help puts a smile on the face of our Lord. The Lord's smile sets deep in my heart. I want my Lord to be proud of me."

I said, "I am proud of you, too."

After hugging Mr. Walton, I told him about my "Gratitude Journal" and how I jotted down things that I was thankful for. I told him how thankfulness helped me to stay positive and focused during a time when I was unemployed and worried about finding another job. For me, this was a tough time so I started listing what I was grateful for on a daily basis, in my journal. My friend understood tough times and being thankful for the day.

After my accident, I wrote in my journal: "Forgiveness is the gift we give to ourselves. Being able to forgive allows us to see the blessings in a bad situation. Forgiveness and love conquers all wrong doings." I listed the blessing of friendship as a gift of love from God.

With tears in my eyes, I looked at my brother in the Lord and told him that he was listed in my journal as a blessing from God. Mr. Walton was a gift to me during a time when he was sorely needed.

All too soon, three years after my accident, life changed for him as his health began to fail. Mr. Walton, in his early fifties, had a massive stroke and died. This was devastating to me as well as to his family and loved ones. On the day of his funeral, I was honored to give tribute, a eulogy before his family, friends, and church members. I explained how Mr. Walton made time to help me when he really did not have any extra time. I told the congregation, I could have called my friend by his first name, but I chose to call him Mr. Walton out of respect for having a pure heart. Having a heart to follow Jesus is a true blessing. After a two-hour service my friend was then buried next to his grandmother whose name was inscribed by a nail on a concrete headstone.

Sometimes I drive out to this peaceful cemetery, visit Mr. Walton's grave, and pull any weeds that might be growing near his headstone. In reflection I say, "Thank you, God, for sending me a friend, someone who could step in and take my place while my body was healing from this accident. Lord, I know that we are just a vapor, and soon we will vanish away. Before I vanish, may I leave a vapor trail of gratitude for how You love me unconditionally. Lord, may Your unconditional love spread through me."

Chapter 17

Strength and Courage

LIFE IS FULL OF UPS AND DOWNS, twists and turns, but in time the negatives fade into the background. The aftermath of the accident was behind me. Surgeries were successful. My orientation and mobility internship and course work were finished. There was one more final examination to complete before I would receive my Orientation and Mobility Certification. This final was called a "Drop Off Lesson" and it involved using all the orientation and mobility skills I had learned and practiced during my training sessions in Houston. I had knowledge of how to use a cane for determining my location on stairs, in an elevator, on an escalator, and in walking through a revolving door. I knew how to detect my direction of travel on a street with traffic and pedestrians. If I veered into the street I learned how to use my cane to quickly get out of the street and back on the desired pathway. I was confident in my ability to travel in a safe and efficient manner.

Early on a Saturday morning in downtown Houston, Texas, my instructor met me in the parking lot of a church. After our greetings, he then placed a blindfold over my eyes and guided me to his car. After a ten-minute ride his car came to a complete stop and the engine was turned off. The instructor helped me get out of the car and walked me to the side of a building. He told me that I was standing on the northeast corner of a parking garage and that I was facing Main Street. My back was against the side of the building. My instructor then said he would meet me at the Corner Café at Main and Rusk. Within seconds, the instructor left me standing alone as he

walked away to his vehicle. I heard the car door open and close before the instructor drove away from where I was standing.

It was my job to determine my given location and the correct direction of travel. I stood at my drop off location with my back against the corner of the building. Before taking one step, I asked the Lord to show me the way through the darkness and help me to discern the correct direction to travel.

According to the noise, I soon determined that vehicles were traveling east on a one-way street. Pedestrians were walking on the sidewalk traveling east and west. I was using their sound to determine the location of the street itself before I moved away from my drop-off location. After lining my cane up with the side of the building, I turned to the right and started to walk in a westerly direction. I held my cane with my left hand and moved it from side to side, right to left, across the concrete to make sure I had a clear path of travel. My right hand was lightly touching the building to help me maintain a straight line of travel. I could hear the pedestrians walking on my left side along the sidewalk.

The sidewalk was crowded and people were making their way around me, offering no assistance at all. Finally, I asked a person where the café was located and they said down the street. Not being able to see, I had no idea where down the street was. I did know that the street was one way on my left side and I could slightly hear the sound of the traffic in front of me so I knew I was approaching an intersection.

In preparing to cross the street I slowly moved into the middle of the pedestrian traffic for safety. The other pedestrians were stopped, waiting for the light to change so they could safely cross the street. Surrounded by people, I spoke out and said, "Is this the Rusk Street crossing?" I got several answers, "Further down the street." "No, it's the next street." I replied back and asked, "Is Rusk Street ahead of me?" I heard "Yes." That was the information I needed to know, and

that was good news as it verified to me I was traveling in the correct direction.

When the light changed, the pedestrians moved forward and I moved along with them, using only a slight sweep of my cane so as not to trip anyone. I could hear a change of street surface as people stepped off the curb to cross the street and then onto the next curb. I followed with my hearing and slowed my pace so I would not miss the drop-off at the curb. After stepping into the street, I used a wider sweep with my cane to find the curb on the other side. Once located, I quickly stepped out of the street and continued to walk forward, making my way down the sidewalk to the next intersection. The pedestrian traffic was my clue for traveling in a fairly straight line.

My cane helped to locate objects such as newspaper stands and other items that were in my pathway. The training I received in the use of a cane was invaluable as I was able to detect dips in the sidewalk and navigated around utility poles that were in my pathway. Communication with other pedestrians helped me to determine when I was near the corner of Main Street and Rusk. One lady informed me that the café was to my right after crossing the street. She also told me, "That's in the area where the mounted police officers practice and often stop to eat breakfast. I hope you get to see them."

As the pedestrians stopped for the changing of the lights and the crossing of Rusk Street, I stood amongst the crowd waiting for the sound of movement. The light changed, the traffic surged on my left, pedestrians began to walk, and I crossed the street with them and located the opposite curb. I kept my cane on the edge of the curb so I could maintain a straight line of travel to the right and not veer into the street. The traffic on Rusk Street was now on my right side and the pedestrian travel was behind me. There were a few people walking around on my left but I could not determine a definite direction of their travel. Before taking too many steps, I waited for stronger cues as to the location of the café.

The sounds made by horses' feet were faint in front of me as I began to take steps along the edge of the street. It took a few minutes to localize on the sound as the wind suddenly became gusty. Finally the wind stopped and the sound of the mounted police officers increased. I knew I was close to the front of the café.

Auditorily identifying my destination, I used my cane in a full sweep technique to walk to my left across the sidewalk to locate the café. Once my cane hit the glass front of the building I stopped to listen for the opening and closing of a door. The squeaky sound of the door was apparently on my right. I kept my cane in a position to trail the edge of the building as I walked toward the sound. Locating the door with my cane, I opened the door and walked inside the café.

My instructor met me inside and said, "Job well done. Let's sit down and have a cup of coffee." That hot coffee tasted so good and I smiled at the sound of the mounted police officers that were eating breakfast. After the first sip of coffee, I removed my blindfold to see what I was hearing. I sat in silence and thought about the strength and courage it takes for a person to conquer adversities in life.

Completing all the requirements for my position was a milestone. Even I had a hard time believing what I had accomplished in the midst of the accident, physical therapy, and surgeries. I proved to myself and to others that by taking life just one step at a time, moment-by-moment, great things could be accomplished. The Lord answered my prayer for safe pastures and protection, the strength to restore my health, and to rest in His will. He provided my needs and gave me the courage and determination to face what was ahead. He answered my silent prayer: "Dear Lord, please reach down and pick me up, throw me over Your shoulder, and carry me through this most difficult time."

Chapter 18

Simple Moments of Life

FINALLY SETTLING INTO A DAILY work routine again was definitely welcomed. On the way into the office each morning, fresh hot coffee was brewing in the main entrance to the building. My routine was to pour a cup, add a little milk, and say, "Isn't life grand!" before heading to my work area. I had pushed through the pain and injuries and was keenly aware of the goodness and mercy that was all around me. I felt total peace and it was wonderful.

Often times at work, I would have one of my Border Collies, Rocky, with me for the day. Rocky encouraged a group of first grade students who were struggling to read. In their classroom, these students would sit on the floor with a big pillow and read to Rocky. He would either lie in the student's lap or on the pillow itself. He helped to build confidence in each one of them, as they would read to him without hesitation. Their skills may not have been perfect, but Rocky never corrected them or read for them. He simply listened and encouraged the slightest try. The teacher, Mrs. Sims and I enjoyed seeing the progress that was made every time Rocky met with his young friends. Mrs. Brown, the dyslexia specialist, was amazed at the current progress the students were making in their ability to read. She commented on how interesting it would be to see the student's long-term progress.

Fifi was instrumental in encouraging me to have Rocky certified as a therapy dog. She knew that Rocky had the temperament for being around young students, and that he could play a part in their learning process. She had therapy dogs herself so she was able to make

arrangements for Rocky to take his test in the area where she lived. Rocky and I drove three hours to meet Fifi and the American Kennel Club certified instructors in Nacogdoches. Rocky wore a cotton red bandana around his neck while we watched and waited for the other dogs to take the test.

Rocky was the last dog tested. The ten test items included heeling on my left side, walking through a crowded area with loud noises, walking around wheelchairs and matching his pace to mine on and off lead.

On command he was required to come, sit, down, and stay. Next, Rocky was patted roughly to see how he would react. The last item on the list to pass was a sit and stay on command while I walked out of his sight for five minutes.

Rocky passed each request without any question of his ability and his score was perfect. Fifi and I were so proud of him! After thanking Fifi for her help, I said, "I can't wait to have Rocky's school picture ID made so he can be an official volunteer in the school."

Fifi said, "Always put a bandana around his neck when he is going to school. We want him to know that he is going to read with the kiddos. Clip the identification badge to his bandana so people will know him by name."

After completing Rocky's certification test, he and I followed Fifi back to her house to look at her remodeling projects. She had purchased an old home, built in the early 1800s, on two acres along a railroad track that ran from Texas to Louisiana. Her father now lived in a nursing home in Nacogdoches. So Fifi used this restoration project to keep her mind off the loss of her mother and her father's failing health. She visited her father daily, ate lunch with him, and made sure he was cared for properly. In between the nursing home visits, she would work on her house. It turned out that this old house was the beginning of a major restoration project that would later prove to be too much.

Standing on her front porch, Fifi told me how she inspected the lumber to make sure each board was perfectly straight, and free of holes, knots or defects. The pine lumber used in this project was milled two miles from her house so Fifi was able to inspect the boards individually. Picking up an extra board, Fifi showed me how she selected the best boards.

She explained, "Ter, take your time, and move your eyes slowly down the board. Don't get in a hurry. Don't look away until you're finished. Stay focused and keep your mind on what you're doing."

Even with her short stature, Fifi was an expert in sighting down the long axis of a twelve-foot board for straightness. I understood what she was saying as I looked at her porch. The finished product was a masterpiece. Every board was perfect with the nails placed in a perfectly straight line.

The front porch would have a story to tell all of its own. It became a favorite gathering place for Fifi and her guests. White wicker chairs were waiting to be enjoyed after guests walked through the double gates of the picket fence. What a picture of Southern hospitality.

Ice-cold lemonade was served in glass mason jars to her guests. Grace Anne, a rescued cat, would wander around and eventually end up in someone's lap. Quite often, she just occupied one of the wicker chairs by herself as she enjoyed another nap in the cool breeze.

Another part of Fifi's project was to build a cedar barn at the back of her property. Remembering an old cowboy bunkhouse and barn on the King Ranch, Fifi built a similar version on her property. She built hers out of cedar planks with two limestone rocks leading up to the front porch. An antique bed, a washbasin, and an original pot-bellied wood stove made her bunkhouse look authentic. A metal stovepipe stood tall above the roof. On the front porch, sitting on a hand-cut tree stump, was Mr. Faust's two hundred pound blacksmith anvil. Horseshoes and a rounding hammer were placed around the anvil. In keeping with the authenticity from childhood memories, Fifi topped

off the barn with a final display of art. Waving across the tin roof was a state of Texas flag painted in brilliant colors of red, white, and blue. The flag stood as a landmark for the small town as travelers would often stop on the side of the highway just to look at the barn.

The sun was beginning to set and I needed to get home to feed before it got too dark. As Rocky and I were leaving, I pulled off on the side of the road just to admire the barn. I called Fifi when I got about an hour from my house to let her know I was safe. We talked until I pulled up in my driveway. I told her how proud of her I was for taking on such an authentic project.

Fifi told me, "The only thing missing in the barn is two miniature donkeys."

After the end of the conversation, I wondered how long it would take her to find two donkeys. Knowing Fifi, she would find a matching pair within weeks.

Within a month, I received a picture of Fifi and Jubilee, a miniature Sicilian donkey with huge, dark ears. What a pair they made sitting in the front seat of her brand new red Chevrolet truck. All you could see were two long ears on the passenger side and a little lady wearing a white Stetson hat sitting behind the steering wheel. I laughed out loud as I thought about a donkey sitting in the front seat of Fifi's truck braying as they drove home together. From that moment on, Jubilee was one lucky donkey. This was the beginning of a tight bond of love between him and his new owner.

Fifi called me a few weeks later to tell me how Jubilee would follow her all around the property, nudging the back pockets of her overalls as he begged for animal crackers. She also purchased another donkey that she named Hope Rose, an older donkey that was used to protect a herd of cattle from coyotes. Being raised on a large ranch, Hope Rose was not as trusting with people as Jubilee. I could tell that these two donkeys brought laughter into Fifi's life. They were also pretty good "watchdogs" because they would let you know when something

was about to happen. While Fifi and I were talking on the phone, I could hear the two donkeys braying in the background. Within seconds, I heard a train whistle. We would laugh and Fifi would say, "Here comes the train from Bobo. Here comes the train along the Houston, East and West Texas line." We would both laugh and say, "The porter is calling out Tenaha, Timpson, Bobo and Blair." Tex Ritter sang a folk song about the railroad tracks, which ran less than one hundred feet from Fifi's fence line.

Fifi would always ask how Rocky was doing with his reading program. We were both so proud of him. I boasted and said, "Our boy Rocky, who was once abandoned and left in an animal shelter with no pedigree just won the Best Practice Award at our local Regional Educational Service Center for his efforts in helping dyslexia students learn to read. The school administration recognized Rocky as a valuable tool in motivating students with dyslexia to overcome their fear of reading. Hanging on the wall in the administration office of my school district is an eleven by seventeen picture of a first grade student reading to Rocky."

"Wow, what an accomplishment," said Fifi.

I continued to tell Fifi that Rocky made friends with a student at school who was in a wheelchair. David had a life threatening health condition and asked to pet Rocky when he saw him at school. Rocky somehow knew that David needed unconditional love. The two bonded instantly. David could not physically lean over in his wheelchair to pet my dog, so Rocky would his put his front paws on David's seat. The two were face to face as David laughed and hugged Rocky with both hands.

Fifi told me to make sure that Rocky visited David as much as possible because the unconditional love of an animal clearly brought happiness to this little boy. Taking her advice, I made arrangements with my boss and the school principal to take Rocky, during my lunch break, twice a week just to see David.

Rocky and David became great friends. Always, when I opened the classroom door, Rocky would walk past the other students and go directly to David. He then put his front paws on the wheelchair and kissed David on the face while David laughed and laughed. On the days when David was home ill, the support staff from our school district would take their lunch break at David's house. We sat with his mother, ate our lunch together, and talked. Rocky would visit each person hoping for a small bite of food.

David was born with a severe congenital birth defect and held a special place in my heart. From him, I learned that many parents of special needs children are so unselfish and humble. I can only imagine how that felt when they found out their child was not perfect, not capable of walking, and had fragile health. Through David I saw a family come together to love, support, and problem solve for the needs of their child. The parent's wants and desires were put on hold without question. A trip to the medical specialist hundreds of miles away or a two-week stay in the children's hospital was not uncommon. Thousands and thousands of dollars were constantly spent on hospital bills, so luxuries like new cars were out of the question.

Family meals involved a two-step process. First was to prepare food for the family. Second was to puree food for David so he could be fed through a gastrostomy tube, a G-tube. Mom was an expert in selecting the proper food for her son. Feeding involved filling a bag with pureed food and hanging the bag high enough so food could slowly flow through a tube connected into David's stomach. After giving thanks, the family made eating and feeding fun as they gathered at the table for their evening meal. They talked and laughed, simply enjoying their time together.

Much time and energy went into preparing just for the day. A family outing meant loading up a wheelchair, oxygen, and medical supplies before the trip even started. From David, I saw what being a family really meant. Unconditional love was first and foremost in the life of

this family as together they stood strong. I admired their strength and courage.

David loved Christmas lights, so his father made sure multi-colored lights were hung all over the trees and on the edge of the house in the backyard. The sound of Christmas filled the backyard every evening all year round when the sun went down. David and his family would gather outside every evening just to watch the smile on David's face when the lights were turned on. David and his grandmother would often sing their own Christmas song they titled, "Grandma Got Run Over by My Wheelchair." This simple time of happiness brought a silent peace to a family that knew David would never grow old. Together they learned to enjoy and celebrate the small, simple moments of life.

Over about a six-month period, David's health was rapidly deteriorating on a daily basis. When the day came for David's memorial service, his parents requested that Rocky be in attendance. My dog wore a Christmas bandana, even though it was summer time, and stood in line with me to speak to the family. Rocky would extend his paw for a handshake in turn for a hug or a pat on the head. David's mother thanked Rocky for being a good friend to her son. I thanked her for letting us be a part of David's life.

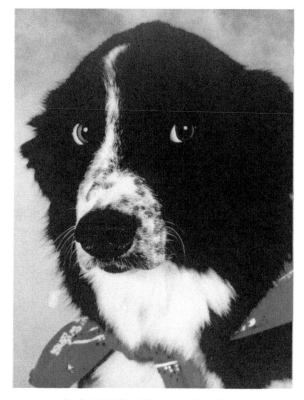

Rocky McMullin - Elementary School Picture

On my way out of the church, I removed Rocky's bandana and lead. He was so good about heeling and never leaving my side that a lead was really unnecessary. After opening the doors, I noticed four squirrels chattering around the grounds of the church courtyard. I am sure they never thought about a dog walking down the sidewalk, but Rocky immediately thought that chasing those squirrels would be great fun. So after looking at me then looking back at the squirrels, I said, "Go." Rocky took off barking and chasing the squirrels around and around the courtyard until the squirrels ran up a tree. Rocky gave each one of us who had the pleasure of seeing the moment a good laugh before he came back to me to go home.

Chapter 19

Turning Devastation into Determination

GOING TO WORK THE NEXT DAY was hard. David's death left a hole in the hearts of the teachers and staff members who worked with him. But we all knew he was no longer suffering. This loss at such a young age once again proved how fragile life could be. Finding peace and excitement in the moment is a gift. As I walked by David's classroom, I thought about his smile and laughter and how he enjoyed the inspiration of Christmas. I thought about his family, and how they gathered together to care for him, to make his day the best it could be. It took a lot of inward strength and faith on their part to make the best of a heartbreaking situation. Surviving life's circumstances takes a lot of courage.

Courage is something that can turn devastation into determination. I saw how one of my vision students handled the outcome of a serious eye condition. Jack at the age of twelve was diagnosed with retinitis pigmentosa, an eye disease that causes retinal degeneration. Some people with this eye condition maintain healthy vision throughout their entire life while others have a severe vision loss. Jack never once questioned why and remained positive about his visual condition. Jack held on to the reflections of encouragement from his family and from God. Encouragement helped Jack to move forward with his life.

I had the pleasure of working with Jack until he graduated from high school. Jack had some usable vision and needed very little visual

support at first. He was a visual learner and utilized print material. As his vision teacher and orientation and mobility specialist, I made sure he had access to large print books, bold lined paper, and dark marking pens for writing. A dome magnifier was provided in case there was material that was too small to read. Jack also used a portable electronic magnifier if he needed to read a price tag or print that was extremely small.

At home, Jack was provided with a computer system, a scanner, and technological programs that would read the text on the computer screen. He was also provided with a system that enlarged written material to any selected size when he wanted to read visually.

Jack worked hard to complete his schoolwork on a daily basis and to maintain an A average. When he entered into high school and was old enough to drive, he obtained a driver's license. His family bought him a truck which Jack made sure was always clean and polished. Now having this own transportation, Jack's desire was to work part-time after school during his junior and senior year. The truck was a gift that made this goal possible.

Jack applied for a job at McDonald's about five miles from his home. During the interview he explained to the manger about his visual impairment and his visual needs. The manager hired Jack and provided Jack with training and a large computer screen so that he could place orders in a timely manner. I would visit him occasionally on the job site and was proud of his accomplishment.

At school, I met with Jack's teachers so they were informed of his visual needs. I would follow up with emails for problem solving any concerns on a regular basis. Jack's parents give me permission to talk with his vision specialist and to review current eye reports so I would be aware of any changes in vision. It seemed like Jack's vision was stable.

He and I discussed learning Braille and cane techniques in case there might be a need in the future. It was hard on his family to think about

Jack becoming a tactual Braille reader instead of remaining a visual learner. After a few visits with his family, we all decided that gaining knowledge in Braille would be beneficial even though we thought his vision was stable. The plan was to start with identifying Braille patterns during the school year and for six weeks in the summer. This would allow time for his family vacation and work schedule.

Having set a schedule for the summer, I planned a trip, my gift to myself, to go horseback riding and camping in Wyoming.

Jack had almost completed his junior year when he noticed a decrease in vision. This was a bit of a shock as now the use of Braille and a cane was becoming a sudden reality. Jack was brave and faced the outcome with courage and the grit to hold onto the future. Knowing it was no longer safe to drive, he handed his truck keys back to his dad and said, "Thank you for your encouragement and for the truck. It is no longer safe for me to drive." Special arrangements were made for transportation so Jack could continue his work schedule until May.

Jack called me on my cell phone to tell me of his decision and of his desire to practice with a cane and to gain further knowledge of Braille. This all occurred two months before school was out. My lesson plans were in place, and Braille patterns and cane techniques were started immediately. I cancelled my trip to Wyoming so I would be available to work all summer with Jack. The family vacation with Jack's parents and grandparents was rearranged. The grandparents came to visit Jack in the summer during their vacation time. I knew that this situation was devastating to the entire family. Although Jack still had some usable vision, the priority to teach Braille and cane skills was set in place.

Jack and I worked at school for the remainder of the school semester on Braille patterns. He was beginning to recognize similar alphabetical code patterns, the dot placement, by touch and sight. We then built on the patterns to produce words. The plan was to learn as

many Braille codes as possible during our time at school and to continue with the lessons throughout the summer months. Progress was being made and Jack was introduced to the entire alphabet by the end of the semester. Jack was gaining knowledge as a tactual reader and relying less on sight recognition.

During the summer, while Jack's grandparents were visiting, they provided Jack transportation for cane lessons. Jack and I met on the campus of Texas A&M to learn how to cross streets, enter buildings, locate and climb stairs, and to ride a bus while using a cane. As we walked throughout the campus environment Jack and I made a lesson out of every step.

When it came time to practice a railroad crossing we timed our lesson on the west side of campus along the railroad tracks. It was not uncommon for freight trains with five engines to pass through this area a dozen times a day. The one-hundred-car trains were about a mile long and, depending upon their load, traveled at a top speed of sixty miles per hour. After hearing the train approaching, Jack and I would stop by the crossing gates to determine the direction of travel, distance away from the crossing gates, and when we could cross safely. Jack was smart and full of common sense so training him was fun and pleasurable.

As Jack and I worked two and three days a week all summer, I got to know his family on a more personal level. His mother and I were colleagues in the school system so we knew each other. His father was a professor at A&M, and his grandparents were in the ministry in East Texas. Grandpa, Mr. Jim, and I developed a special bond, as he loved horses as much as I did. So I asked the family about Mr. Jim bringing Jack to my house so they could ride horses together. It was exciting to watch Mr. Jim ride Zandy around the arena as if he had ridden him all of his life. Although Cloud was old, he was safe and still strong enough for Jack to ride. Cloud was perfect, as he would simply follow the railing around the arena. It was heartwarming to see a grandson and his grandfather enjoy their time together. I knew Mr.

Jim was grieved over Jack's vision. But Mr. Jim knew that Jack would dig down deep inside to face his fear and he would gather the courage to keep moving forward with his life. Jack had an inward determination to make something out of his life, with or without sight.

As the summer progressed, Jack learned to read Braille codes, pattern after pattern, until he gained enough knowledge to produce his own Braille. He started learning with a manual Braille typewriter, called a Perkins Brailler. Because Jack was intent on learning Braille, he learned how to use the Perkins in no time. He knew how to locate the two side knobs and to correctly insert the braille paper. The Perkins made a noise when Jack would hit the carriage return level to advance the paper forward. After locating the correct finger placement Jack developed simple sentences using the correct Braille codes. As Jack produced his own Braille, the special paper with grooves on the side would advance forward to avoid crushing the raised dots made by the Perkins. By the middle of August, Jack was producing and reading his own Braille sentences.

During his senior year, Jack and I continued with our Braille and cane training at school. His class schedule was just from first to fourth period as he only had a few core subjects to complete. Jack was provided books on tape for his class, which allowed him to listen to the lessons and stories. He had access to large print books and teacher notes for his classes. At home, Jack continued to practice his Braille, and as his knowledge increased, I switched him to portable, technological equipment. A Braille note-taking device with word processing capabilities, voice memos, email, address list, book reader, and a scientific calculator increased Jack's independence.

Jack had the convenience of using wireless accessories such as printers, Braille embossers, and keyboards. This equipment had the capability of being connected to the teacher's computer so lessons and assignments could be transferred into Jack's note taker. In this way, Jack had information as the teacher was teaching the lesson. Tests, final examinations, or special projects could be emailed from

teacher to Jack or from Jack to teacher for grading and feedback. This technological equipment would help Jack complete his senior year and prepare for his future years in college. He was determined that his visual impairment would not stop him from achieving his dreams.

After graduating from high school, at the end of May, Jack acquired a guide dog. This was a wonderful assistant for Jack as he was leaving for college in two months. His black Lab, named Sam, was trained to keep Jack safe while traveling from one location to another, and actually to any place that Jack needed to go. Sam's job was to provide freedom and greater independence for Jack. I told Jack that Sam would become a loyal friend to him in no time and that unconditional trust makes a stronger bond between dog and man.

Jack's parents were from East Texas originally, so they decided to relocate their home and jobs to Nacogdoches. Together the entire family packed up and moved to be close to Jack as he attended college at Stephen F. Austin State University. This college offered a training program in the area of visual impairments for students who wanted to make this their profession. Jack's father resigned his position at Texas A&M and took a job at Stephen F. Austin and his mom resigned from her employer and accepted a teaching position in Nacogdoches. The strength of this family was powerful as they held together to deal with this crisis. Sam, Jack, and his family became even closer as his vision decreased from partial sight to light perception only.

In August, after Jack settled into an apartment close to his college campus, he called to tell me about his classes and professors. Jack started during the second summer term in July, so he could become familiar with the campus and his apartment as quickly as possible. Jack had some of the same professors that trained me in the field of vision and orientation and mobility. He said his desire was to become a teacher of the visually impaired so he could help students with their own vision loss.

I asked Jack where he was going to church. He told me he found a small Baptist church in Nacogdoches with a great college leadership program. Jack said to me, "Some of my church friends pick me up and take me to eat or to a movie on a regular basis. On Thursday afternoons, we go together to visit a local nursing home in Nacogdoches." When Jack told me the name of the nursing home I said, "Jack, that is great! I have a friend, Mr. Faust, living in that same facility." I told him about my friends, Mr. Faust and his daughter, Fifi. Jack said he and Sam would stop by and visit Mr. Faust on Thursday.

It pleased me to think that Jack and Sam would be visiting my friend in the nursing home. I was proud of Jack for moving forward with his life and becoming involved in church, college, and the community. I knew that Sam would play an invaluable role in helping Jack become more independent.

Jack and I share a special bond: a bond between student and teacher, between friend and friend, a bond of overcoming individual struggles, and a bond through achieving an education. Jack was not going to allow a loss of sight to create a roadblock for achieving success.

Before ending our conversation, Jack said, "When are you going to ride in Wyoming? You missed the trip last summer to work with me on Braille. Thank you for putting my needs first, your kindness certainly made a difference. But now it is time for you to take your trip to the mountains."

I replied, "Actually, I leave next Monday to fly into Jackson Hole, Wyoming. My friend, Sally, who lives in Wyoming, is going to pick me up at the airport. From Jackson Hole, we drive through the Tetons and Yellowstone National Park on our way to Cody to go horseback riding with a group of archeologists from Tennessee. These archeologists are searching for Indian artifacts high in the mountains outside of Cody. Sally, a naturalist, who planned and arranged this trip, invited me to ride along with them."

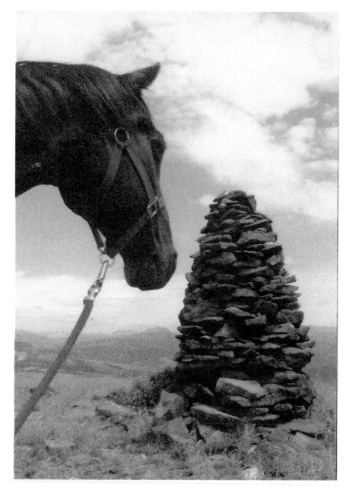

In memory of Midnight.
Sally J. Wulbrecht

I said to Jack, "You know, if I had gone to the mountains the year before as originally planned I would have missed out on this archeological search in the mountains. You were my priority and I knew in my heart that I needed to help you with Braille and cane skills first. In turn, God rewarded me with a trip of a lifetime. Things worked out for both of us. God rewarded me for helping you."

Chapter 20

Reflection on the Past

TWO DAYS AFTER LANDING in the mountain state that I love so much, I was excited for a horseback ride through the mountainside of Cody, Wyoming. This was not a normal horseback ride, as a group of archeologists, intern students, and my friend Sally were on the hunt for the remnants of a Native American wickiup and a sheep trap in that area.

A local archeologist, Mr. Edgar, from Cody Wyoming rode with us. His knowledge of the mountains was invaluable in locating the remnants. Mr. Edgar's quite demeanor would not brag about the fact that he was an internationally acclaimed archeologist, historian, author, naturalist, conservationist, world-class sharpshooter, and hunting guide. Mr. Edgar even received national recognition from the Smithsonian Institution.

As Sally's guest, I was simply looking forward to learning from this special group of people. The group gathered along the base of the South Fork of the Shoshone River, several miles West of Cody. We packed up our gear and met up with two cowboy outfitters and three trailer loads of horses. The outfitters were excellent horsemen and trainers as they matched horse to rider. They knew that most of the riders did not have the experience that Sally, Mr. Edgar, and I had with horses. Sally and Mr. Edgar were given Rocky Mountain horses to ride and I was given a mustang that the outfitters personally adopted and trained. My horse, Gus, was a tall dark gray gelding with a black mane and tail.

I remember how good it felt, swinging myself up in the saddle, collecting even reins, and just sitting in the saddle while the other riders mounted their horses. I was third in line behind the cowboys, as I knew there would be less dust towards the front of the line. The group fell in line behind me, and bringing up the rear were three large female mules. The mules carried the sawbuck, pack saddles, and canvas panniers loaded down with our gear and food. These strong mules were outstanding, never missed a step, and stayed in equal stride the entire time.

The solid black Rocky Mountain mare that led the mules wore a bell around her neck, and the sound provided a clue to the cowboys as to the location of the mare and the mules. The mules willingly followed two cowboys, ten riders, and the mare for miles and miles, round and round, up through the mountainside. We crossed several ice-cold water crossings and climbed switchback after switchback until we reached the mountain trail that led to the area of the sheep trap.

When we reached the top, the panniers were unloaded, giving those magnificent animals a break from the heavy load. The cinches were loosened on the horses as they were tied to the trees. The view from the top of this mountain was breathtaking, and the glacier-formed valley down below created quite a memorable moment. I stood in silence to watch an eagle soar through the valley on the invisible updraft of the wind. The cowboys started a small cook fire and placed a handmade grill over the open flame to cook hamburgers. I stayed with the cowboys and enjoyed freshly brewed hot coffee while the others set out on foot to complete their mission.

Shoshone Sheep Trap used by the Mountain Shoshone to trap and coral Bighorn Sheep Wyoming
Sally J. Wulbrecht

In a clearing, using a global positioning system (GPS), the head archeologist was able to get a reading as he began the search for the remnants left behind by the Mountain Shoshone Indians, often called Sheep Eaters. A tiny arrowhead was spotted by one of the students and the specific location, pictures, and GPS coordinates were logged in for the records. Located at the top of the gully were the remains of trees placed in a specific pattern. These trees formed a narrow driveline leading to a catch pen that the Indians used for trapping bighorn sheep.

Shoshone Sheep Trap used by the Mountain Shoshone to trap and coral Bighorn Sheep
Wyoming
Sally J. Wulbrecht

Surviving off of sheep, the Indians followed them high into the mountains during the summer and down through the foothills during the cold winter months. The Indians who once roamed this area migrated there from Montana and Idaho.

After the group gathered and recorded the needed information, they walked back to the camp. Hamburgers were sizzling on the grill and a fresh pot of coffee was brewing over the red-hot coals. The group showed me pictures of their findings before we all ate lunch. After a short period of time, we worked together to dismantle camp and pack the contents on the mules for our trip back down the mountainside. I hated to leave the peaceful environment but we needed to be at the base of the mountains before dark. The horses were untied, cinches tightened, and riders mounted before we made the first step back

down the trail. We lined up once again for our two-hour ride back down to the base of the Shoshone River.

Once we made it back to the base of the mountain, we unloaded the contents from the panniers and took the pack saddles off the mules. Next we unsaddled the horses and removed their bridles. Every piece of equipment was put back in the proper place in the horse trailer. Bridles and halters were hung on a nail under each horse's name. Each horse was brushed and its hooves cleaned out before being turned loose in the meadow to graze. I gave Gus a pat and thanked him for a safe ride and for being mindful of his environment.

In order to be ready for our ride the next day, we drove to the T Bar Ranch, north of Cody, to camp for the night. The T Bar Ranch had our meal ready by the time we had the tents set up. After a delicious meal of steak, baked potatoes, and peach cobbler it was time to get some rest.

Morning came early with a beautiful sunrise and a cold mountain breeze. The ranch cook had hot coffee ready while he was preparing bacon, eggs, and sourdough biscuits outdoors over the campfire. After eating, Sally gathered the group together and said, "Today, we have permission to ride through the Beartooth Mountains on the eastern side of Yellowstone National Park. We have a full day ahead of us with several river crossings. Our ride will not be up and down switchbacks like it was yesterday. We will have beautiful scenery for miles, as we ride through the rolling foothills toward the high desert and up to the high plains looking for an Indian wickiup."

The cowboys were introduced as we made our way to the horse barn to catch and saddle our horses. Since we were on a true working ranch, most of the horses were stock horses that were used to work cattle. The catch pen was full of horses: Morgans, Quarter Horses, and one Appaloosa, with their colors varying from palominos and buckskins to dark bays. Most of the riders selected the horses based on color except me.

I told them, "The color doesn't matter, a good horse with a quiet disposition is far more important to me."

Since all these horses were solid under saddle, there was not a bad one in the bunch. I spotted a beautiful dark bay Appaloosa gelding with a snowcap hip that appeared to be about eight years old. I asked one of the cowboys about him and was told that this horse was born and raised on the ranch and was professionally trained and shown as a stock horse.

The cowboy said, "You have a good eye for horses. That is my favorite horse to ride on the trail as he is solid minded and sure-footed."

Once selected, one by one, each of the cowboys swung his loop over the horse's neck so each rider could then halter their horse. As the red dust settled in the pen, we all worked together to brush and saddle our mounts.

After we mounted the horses, we asked the Lord to protect us as we rode. The first river we crossed was so wide it made me dizzy as the water rushed around the rocks creating a sinking swirl. We had a three hour ride ahead of us as we began to make our way through the high desert country of Sunlight Basin and upward toward the high plains on the east side of Yellowstone.

An occasional roll of thunder and cool winds blowing in our face warned us of a possible weather change as we rode single file along the trail. In case of a summer storm, we were prepared with rain slickers and hats as we continued our ride. Set up high along the mountainside was an opening that gave us a view of the east side of Yellowstone. Down in the valley out of our sight, we could hear cowboys working their cattle in the steep canyons below. Bellowing sounds of cows echoed and carried for miles on the tail of the winds that blew strong around the mountains.

Once we reached the GPS location, the riders dismounted and unsaddled the horses. Sturdy leather hobbles were put around the front legs of the horses before the bits and bridles were slowly lowered out of their mouths. Ready for a rest, the horses dropped their heads and grazed on the lush grass. It was my job to watch the horses while the others walked up higher in the mountain to locate the wickiup. The lead cowboy left me with one of his pistols for protection because he had seen bear scat along the trail.

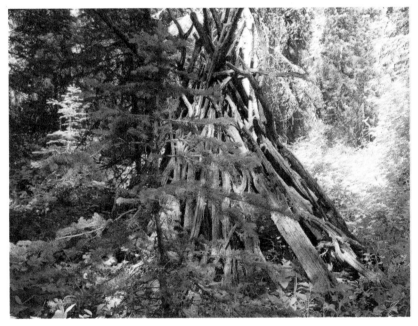

Indian Wickiup
Wyoming
Sally J. Wulbrecht

Watching the group walk away, I was keenly aware that besides the grizzly bears, there were also mountain lions and wolves in this area. With sunrays filtering through the trees and a nice warm breeze blowing, I sat down on the ground by a fallen tree. With the safety on, I laid the pistol at my side, gently touched the grip with my right hand, and leaned back against the tree to take a rest. That pistol felt real

comfortable in my hand as my ears were tuned for the sound of grizzlies.

I glanced over at the Appaloosa I had been riding and thought of how important that breed of horse was to the Nez Perce. Thinking about my horse back in Texas, I recalled what I had learned when I researched the Appaloosa horses years ago. The Appaloosa played a key role in transporting the Indians through this rough and frigid country. After that thought, I wondered if my own handsome Appaloosa, Joseph Spotted Cloud, was a descendant of one of those fine horses.

My thoughts continued to wander as I soaked up the beauty of the land. I remembered the story of the Nez Perce Indians and how badly they were treated. Chief Joseph the Elder was one of the first Nez Perce Indians to become a Christian. He worked with Washington's territorial governor to establish the Nez Perce reservation. The chief agreed to give up a section of their tribal lands in agreement that the white settlers would not intrude upon the Indians' sacred, ancestral land in the Wallowa Valley region of northeastern Oregon. However, this peace agreement became fractured when prospectors began to invade the reservation land in search for gold. After the discovery of gold, the United States government reneged on their agreement and took back millions of acres of reservation land, and refused to honor the agreement to keep the Wallowa Valley sacred. Chief Joseph the Elder refused to sign a new agreement for a new 10,000 acre boundary line reservation, and refused to leave Wallowa Valley. The bond of trust was broken forever.

My heart sank as I thought of how the elder chief stepped out in good faith to make a solid stand for his belief and for the protection of his tribe. His efforts to promote peace were twisted and turned because of betrayal and greed. A short period of time after this conflict, the elder chief passed on the brokenness in his heart to his son, Thunder Rolling Down the Mountain, better known as Chief Joseph. In 1877,

it was Chief Joseph who decided to lead his people away to a peaceful environment in Canada.

My imagination and the solitude of my surroundings took me to another time and another culture. Mentally, I could visualize Chief Joseph leading his people up and down through these same mountains on a long journey to find a better place to live. Although the sounds of horses' feet, the crying of babies, the silence of starvation, and the brokenness of pierced hearts dissipated a long time ago, the tragic story of bloodshed, starvation, illness, and frozen temperatures forced the Nez Perce Indians to surrender in the Bear Paw Mountains of Montana, forty miles from the Canadian border.

The somber words of Chief Joseph still echo in history: *"I am tired; my heart is sick and sad. From where the sun now stands I will fight no more forever."* Although history's wrongs cannot be undone, I could feel the lingering pain of broken dreams of those who only wanted to live in peace and harmony.

Suddenly, a burst of cool wet air surged in my face as the winds shifted directions. Leaving my thoughts behind me, I stood up, put the gun in the holster, and went to check on the horses. Soon I heard my friends returning. Their search was successful and they were excited to show me pictures of the wickiup they had located. The remnants of the wickiup were in recognizable condition and told a story about the life of the Indians that dwelled in the higher mountainous area of Yellowstone. The group was able to log in the GPS coordinates on the wickiup for future research.

T. A. McMullin

Indian Wickiup
Wyoming
Sally J. Wulbrecht

After all the horses were accounted for, we saddled and mounted for our ride back to the ranch headquarters. I was asked to take the lead behind the head cowboy. That was simple, as I just had to stay on the path that led us back down the mountain. Riding back down the trail, reversing the hoof imprint, I had time to do a lot of thinking. I thought about broken hearts, peace, and forgiveness in my own life. I thought about how we all need each other. I thought about how hurt often turns into anger. There seems to be a ripple effect of anger that crosses from one generation to another.

That day the words *why can't we treat one another, as we want to be treated* took on a deeper meaning for me. After all, we are all God's creation. We were created to live in love, peace, and harmony, not conflict and greed. We are all woven together from the same strand of DNA, the thread that runs through our soul, and connects us directly to God Himself.

Reflecting on the past was humbling and it made me more appreciative of the blessings in my own life. Once again, I thanked the good Lord for just being able to walk. How grateful I was to have

168

the endurance to be able to ride horses once again. I realized that I was blessed to be in good health. If you have good health, you are rich.

I smiled as my horse stepped off in the water to cross the last icy cold creek on our way back toward the ranch headquarters. All the riders echoed me as I gave out a "Whoop!" for safely making our way down the mountainside from the high plains, through Sunlight Basin, and around the area that surrounds the Chief Joseph Highway.

All too soon, my trip of a lifetime came to an end. It was refreshing spending time with my Wyoming friends, but my animals back in Texas were calling me home. Dressed in my comfortable custom made boots, starched red shirt, jeans, and black Stetson hat, I boarded the plane and headed back home to Texas.

170

Chapter 21

Life at Its Best is Tough

IT HAD BEEN MONTHS since I had the chance to sit and visit with my friend Fifi. I was eager to see her and tell her about my trip to Wyoming. Early the next Saturday, Rocky and I set out on a visit to surprise my faithful friend who was so dear to me. After a long drive, we arrived and I parked my truck by her front gate. Rocky and I got out of the truck and I stood by the gate just enjoying the view. An American flag, waving from a tall flagpole, set the authentic scene of her restored home. Varieties of flowers and trees displayed splashes of color behind the white picket fence. It was easy to see why people would stop and comment on the beauty and the tidiness of her place. She worked day and night to restore and maintain her property. The saying, "She worked herself ragged," may have been true in this case.

There was my friend, kneeling on her knees, planting coneflowers in her front yard. The purple, daisy like perennial flowers were gorgeous and the color represented royalty. I could not resist as I hollered, "Those flowers are the wrong color. I thought your favorite color was yellow!"

She looked up just as two donkeys brayed and the dogs started barking. She hollered back, "Hey, Ter, you and Rocky come on in. The gate is unlocked. Let me finish planting these coneflowers and then I'll brew us a pot of coffee."

Nothing compares to being able to spend time with a good friend. I was glad to see and visit with Fifi. I was excited to tell her all about my horseback ride through the mountains and the archeological findings.

During our visit, she had several bouts of chronic coughing and had to leave the room to try and get it under control. She apologized and explained that it was probably a side effect from the inflammation caused by lupus. Fifi's shortness of breath was very noticeable. All too soon it was time to leave, but I was thankful for the few short hours we had together.

As Rocky and I were walking to my truck, Fifi hollered, "Call when you get home."

Waving goodbye to my friend, I said, "I love you."

Driving home, I thought about Fifi's health and how it had changed so rapidly. From that point on, I began to call her every evening around five o'clock to check on her. I knew she would be inside feeding her dogs about that same time.

As Fifi's health continued to deteriorate, I did what I could to help her. Several times, I loaded my stock trailer with hay and delivered it to her for the donkeys. During those hay visits, my friend and I would sit on the front porch next to her wood stove and talk for hours. I can still hear her saying to me, "Many a problem has been solved over a cup of coffee. So let's drink the whole pot." Memories of those visits were bittersweet as I could see the intensity of pain increasing. Her cough was getting deeper, and she had difficulty breathing.

Even though Fifi had a hard time breathing, she visited her father every day to make sure the nursing home employees did what they said they would do. This was an extremely expensive and difficult situation for Fifi to manage because she didn't feel well herself. Her father had worked hard physically all of his life and refused to ever accept a handout for anything. For that reason, Fifi paid at least thirty-five hundred dollars a month for her father's care. She honored her father's way of life.

The following months brought additional changes for all of us. By November, Mr. Faust was in the advanced stages of congestive heart

failure, which was no longer manageable with medication. Fifi's cough worsened and I became more concerned about my friend's declining health. Daily, I would call Fifi to check on her.

I clearly recall our phone conversation on a cold Wednesday afternoon when Fifi sadly blurted out to me over the phone, "Ter, I have lung cancer. The nurse just called and told me I have lung cancer."

There was dead silence on the phone. Neither of us had words to express the sadness we felt in our hearts. Finally I was able to reply, "Then I have cancer too. We will walk through this together. You are not alone because I will be there for you. We are family."

Within three months, Fifi was now in the biggest battle of her life. This dreadful disease had spread from her lungs to the lymphatic system and into her bones. Fifi tried radiation and experimental drugs but nothing could stop the deadly rage that was running rampant throughout her entire body. Her doctors suggested she receive further treatment at MD Anderson Cancer Center, in Houston, Texas.

Even in the midst of unbearable pain, her primary concern was for her father. Fifi told me, "I have to live long enough to care for my father no matter the pain, no matter the suffering." Many times during our thirty-five-year friendship, she told me that indeed life was tough. "Life at its best is tough," was exactly what she said. This time she was looking for a miracle, hoping to have some relief from the challenges of cancer and the pain in her body.

Leaving her small community the second week of March, with her father in the nursing home, and making sure her animals were cared for, Fifi went alone to MD Anderson for three weeks of treatment. Fifi stayed in a local hotel that provided shuttle service back and forth to MD Anderson. Being alone was Fifi's decision as she felt she could then rest every moment she could. With sadness, I honored her choice.

While Fifi was in Houston, she told me, "I just can't die before my father."

I said, "Fifi, please don't worry, I will take care of your father."

I can only imagine the intense pain, as her bones were separating due to the cancer's invasion. The doctors developed a plan to surgically bond the fragmented bones together to help relieve the discomfort. After surgery and a few days of recovery, intense radiation treatments occurred twice daily for two weeks. Upon release from the hospital, Fifi would continue radiation treatments at the cancer treatment facility in Nacogdoches.

I contacted Fifi twice a day while she was in Houston and made phone calls to the nursing home to check on Mr. Faust. Although Fifi called and talked with her father daily, he was unaware that she had cancer and was at MD Anderson. Mr. Faust was developing severe respiratory symptoms along with advanced congestive heart failure and was slowly declining. He rested and slept a lot, so he thought Fifi came to see him while he was sleeping.

When Fifi arrived back home she was absolutely worn out and requested a week off from treatments just to rest. The doctors may not have agreed, but Fifi just needed to be at home, at peace, and in quietness with her animals. Cindy, a friend of Fifi's, offered to drive her to the cancer treatment facility for radiation the following week. Cindy was so faithful to provide Fifi with transportation not only for her radiation treatments, but also to the grocery store, and visits to the nursing home to check on her father. Cindy's mother was in the same nursing home as Mr. Faust so together they stopped and checked on their loved ones. I was so appreciative of Cindy's friendship and help. It was perfect timing and Fifi really needed the help.

Three months after Fifi's return from MD Anderson, Mr. Faust developed a deep raspy cough. Fifi was concerned and made a doctor's appointment for him. The doctor told Fifi that her father had a severe case of aspiration pneumonia and needed to be

hospitalized. Fifi knew his condition was life threatening so she stayed by his bedside for hours at a time. Daily, she would drive home to feed her animals and then return to the hospital to be with her father. Fifi began the process of saying goodbye to her father, knowing she would join him shortly. After being in the hospital for a week, Mr. Faust took his last breath with Fifi holding his hand. He was ninety-eight years old.

As a child, the relationship between Fifi and her father was turbulent because Mr. Faust was verbally abusive. During his latter years, he had had a softening of heart and had mellowed. He asked Fifi for forgiveness, as he was sorry for treating her so harshly. This was an answer to Fifi's lifelong prayer.

Now it seemed it was Fifi's turn to prepare for her journey to Heaven, as the cancer in her body was on the warpath, moving rapidly to her brain. Even during this stage of sickness, Fifi was still thinking of the care and welfare of her pets. She called me at six-thirty on a cold, windy Saturday morning in October, and told me it was time for her donkeys to go to their new home. Within two hours of her call, I had the gooseneck trailer hooked up to the truck and was on the road traveling to her house to pick up Jubilee and Hope Rose. When Rocky and I arrived, Fifi told me how much to feed each donkey and to not let them get overweight. I assured Fifi that her two beautiful, miniature Sicilian donkeys would be properly cared for, their hooves trimmed, and that they would be dewormed on a regular basis. I promised my friend that they would never have to find another home.

Before I left, Fifi told me to take her father's anvil and wood stump that was sitting on the front porch of the bunkhouse. She said, "Daddy loved you and would want you to have his anvil." Loading up two donkeys was much easier than loading up a two hundred pound anvil. Fifi was resting on the couch when I left. We both said, "I love you," at the same time. I told her I would be back next week to check on her. She told me to call her when I got home.

This was the beginning of many sorrowful visits as I began the process of saying goodbye to my dear friend. Her health was declining rapidly and within a week she was in a hospital bed that was set up in her living room. When I walked into her house that next weekend, I knelt down next to her bed to hear what she was saying to me.

With slow speech, she asked me, "Ter, what are we going to do with me?"

My reply was, "Please come home with me. I will take care of you. Please come!"

She said, "I can't do that. I wish to die in my own home and I wish Micah to stay with me until the end."

Micah was her faithful Boston terrier and she wanted to know that he would have the needed closure when the time came for her to leave.

This was her last wish and my last promise to her. "Yes ma'am. We will care for you right here in your home."

And so we did. Fifi's friends, Cindy and her husband, Bobby, were standing next to me listening to Fifi's wishes.

Cindy said to me, "Let's rotate our time so that constant care can be provided. The hospice nurse comes on a routine basis to monitor her condition and she can advise us about her care."

It was our deepest desire to honor the wishes of our friend. Every Thursday, after work for the next three weeks, I drove three hours to care for and sit next to my dear friend. I rested on the couch by her hospital bed so I could monitor her breathing and provide any health care she would need. She especially loved her coffee and every morning we drank a cup. The day came when she could no longer drink coffee, but she still enjoyed holding the cup in her hands close to her chest where she could at least smell the strong aroma. With a heavy heart and great sadness, I would leave late Sunday evenings after Cindy and Bobby arrived to care for Fifi.

I could hardly wait for the following Thursday when I could return to care for my friend. During my time of care taking, Fifi and I would reminisce about our time working together at the small animal emergency clinic, about life in general, and past conversations. Fifi would listen and nod her head occasionally.

One year, Fifi helped me care for a one-day-old abandoned female puppy. She taught me how to feed this little, hair lipped puppy by using a tiny feeding tube until she was strong enough to eat on her own. Because of Fifi's help and advice, we were able to save the life of this tiny puppy that we called Princess. After a few surgeries to repair her hair lip and cleft palate, Princess grew up to be a happy little dog that lived to be sixteen years of age. Fifi saw the good in this helpless dog's life, not the imperfection that was visually noticeable.

Fifi saw the strengths in my life also. She knew I had a glitch in my ability to read and to absorb words, but she saw me as a hard worker and knew I was honest and loyal to the core. As our friendship grew, Fifi became aware that I was teased and called stupid by people very close to me. Fifi always encouraged me by saying, "Imperfections don't control the outcome of life."

Fifi was excited when I was admitted to Texas A&M University and was my number three encourager next to my grandmother and Miss Lili. I remember Fifi and I talking about famous people such as Albert Einstein, Leonardo da Vinci, Walt Disney, and Thomas Edison who had dyslexia. We would laugh when I would add, "And me too!" I told Fifi, "I have a lot of dreams inside of me. My big dream is to achieve my education and then to be successful in any dream that I might have in the future. I am strong in the Lord and I am who God says I am."

Fifi heard what I was saying and said slowly, "I'm proud of your success. Keep dreaming."

As time passed and Fifi started drifting in and out, I tried mentally to prepare for the time when I would say my last goodbye. Even though

I tried, I was not ready. On my watch, it was apparent that the oxygen was no longer effective and her breathing was becoming more labored. I sat next to her and whispered in her ear, "Your mom and dad along with your animal friends are waiting in Heaven to see you. It is my absolute honor to be with you today. Thank you for treating me like family and for being my friend. Thank you for loving me unconditionally, I love you so much."

And so, our last goodbye came that Thanksgiving at three thirty in the early morning when I heard and saw Fifi take her last breath. What a grand friendship and what great horseback rides we had together. Our hours talking about life will stay in my mind forever. She was devoted to her family and to the friends she met throughout her life. Likewise, her friends and loved ones were also faithful to her until the end. Micah was by her side and received the final touch from Fifi before she took her last breath. A short five months after her daddy died, Fifi was on her way to celebrate a new and glorious Thanksgiving in Heaven. God is good and in all things good. The pain and suffering were over and the entering into a glorified body was emerging.

I cuddled Micah in my arms, wiped the tears from his eyes, and told him that his new family was waiting for him. I told Micah he would have children to play with and love everyday. His new family had a big backyard where he and the kids could run and play. All of Micah's toys, dog bowls, chew sticks, cuddly bed, and new family were awaiting his arrival.

After gathering my thoughts, I called the hospice nurse to inform her that my dear friend passed away. The nurse in turn notified the funeral home. I gathered together the funeral attire that Fifi had requested and had her clothing ready when Scott from the funeral home arrived. While I was waiting on Scott and the hospice nurse, I packed up my belongings and got ready to travel home.

Micah's new family came a few hours later to pick him up. I said to Micah, "Job well done, boy, go run and play, enjoy the rest of your life." Before they left, I thanked the family for their kindness and generosity in caring for Micah. I then walked out in Fifi's yard to take one last glance at the American flag, waving tall against the background of the bright red sunrise. The colors behind the white picket fence were fading into the ground. The bunkhouse and barn were now empty of animals, and life itself seemed to be draining from the place she loved so much.

Leaving Fifi's restored home place was hard. It was Thanksgiving morning, and I knew I would miss my friend for the rest of my life. I was especially going to miss our talks and laughter. We never ended a conversation without saying, "I love you." Her friendship was a true and loyal one sent by God. Never did I think, when I first met Fifi in a job interview when I was twenty-one years old, that I would be by her bedside when she took her last breath thirty-five years later. Life proved to me once again that God has a divine plan for each of us and that we are all tightly connected and interwoven into God's plan. He knows the beginning and the end of our days here on Earth.

Backing out of the driveway, I heard the train approaching. This time, the whistle blew with no echo of the donkeys' braying. I thought about the two donkeys, Jubilee and Hope Rose that Fifi loved so much. After absorbing the solemn lonely sound of the solitary train whistle, suddenly I couldn't wait to get home, to drive down my driveway, and see Fifi's donkeys grazing in my front pasture. I wanted to hear them bray at me when I pulled through my front entrance toward the barn.

Being a creature of habit, I knew what Jubilee would do. He will walk over and stand by the truck impatiently waiting for me to open the door. As the door slowly opens, he will nudge the door open with his nose, and place his head in my lap. His big, long black ears will then touch my face. As always, we will talk and talk while I rub the inside of his ears. I will then tell him about my day. Then I will ask him

about his day walking around the pasture, grazing, and playing with his toys. Bashful Hope Rose will stand off to the side under the trees and just look at us, perhaps wondering if Jubilee thinks he is a human instead of a donkey.

Knowing Fifi's donkeys were safe at my house and waiting to see me made leaving my friend's place a little easier.

Jubilee with Hope Rose in the background
T. A. McMullin

Chapter 22

Let the Dream Soar

ON MY WAY HOME, an hour later, I stopped in Nacogdoches to get a cup of coffee and call my former student Jack. He answered the phone and I said, "Happy Thanksgiving." We talked for a few minutes and he asked what brought me to Nacogdoches.

I told him about Fifi and Jack said, "Your friend graduated into Heaven and I graduated from college."

We talked for about forty-five minutes and our conversation was inspiring, as Jack had earned his Bachelor of Science degree with a teaching certificate in the field of visual impairment. He told me about the graduation ceremony and how the audience clapped when his guide dog, Sam, first stepped up on the stage. With a grip on the harness, Jack said, "I followed Sam's pace and walked across the stage with my head held up high."

Jack told me how surprised he was when he realized it was his father who had handed him the diploma. His father said, "Job well done, son. I am proud of you." Jack hugged his father and said, "Thank you for encouraging me. I love you."

Jack said, "The crowd continued to clap as Sam and I walked off the stage. My mother and grandparents were at the foot of the stage waiting for us."

What a moment for celebration. Jack's description of his graduation brought tears to my eyes as I remembered the accomplishments behind my own graduation.

Jack told me he had a job teaching Braille to blind students.

I said, "You are on a pathway to encourage others to overcome hardships and to become resilient. The reflection of the encouragement that you received will be passed on to the students you teach. Jack, I am so proud of you."

Jack asked me if I had started writing about the story of my life.

I said, "In a way yes, I have thoughts in my mind. I made notes on a piece of scratch paper and words of encouragement on a napkin, but nothing formal. I laughed then and said, "I try to remember to put my thoughts in a folder instead of throwing papers on the kitchen table when I walk into the house. When I volunteer with the dyslexia students, I think about my struggles learning to read and how I achieved my education so those thoughts are still strong in my mind. Actually, writing my manuscript is a daily thought. So in a way yes, I have started."

After finishing three cups of strong hot coffee, I realized that Jack and I were now having an adult level conversation, when he said, "I have discovered in my own life, there is never a perfect moment to begin. You just begin in the moment." Jack was right; this was the moment to begin.

Before our conversation ended, Jack went on to remind me of what I once told him when he found out he had a severe visual impairment. "You will never know what is hidden deep inside the essence of your being until you let the dream inside of you out. Let the dream soar on the updraft of the winds just like an eagle soars through the glacier valleys of Wyoming. Gathering the courage to follow your dreams will help you find the true calling in your heart."

It was now ten o'clock in the morning and the coffee helped to keep me awake while driving. When I got home from Fifi's, I rubbed Jubilee's ears, as his head was in my lap, and told both my donkeys how much I loved them. Next, I unloaded my truck, put clothes in

the washer and fed the dogs and horses. Rocky was so glad to see me that he followed every step I made until I got into the house. Being my canine soul mate, Rocky could hardly stand to be out of my sight, and I would say the same about him.

As I started to walk past the kitchen table I thought to myself, "Now is the moment. Organize your notes and thoughts and start writing."

The computer was on the table next to my notes so all I needed to do was to get organized and begin. Sitting down, I glanced at a note I made on a napkin. I read the first note out loud:

"Dyslexia feels like quicksand pulling at my feet."

It seemed very comfortable for Rocky to lie down at my feet as I read my notes. My loyal companion was encouraging me to begin my story *Gathering Courage*, the same way he encouraged his friends to read. After all, Rocky and I were a team in encouraging success.

Dyslexia was first in my thoughts. Dyslexia is why I was called stupid and labeled a slow learner in school. Dyslexia is why I struggled in school. Dyslexia is why I tell my story to a group of young students who are working hard to learn strategies that will help them be successful in school.

Identification and early intervention is the key in helping to overcome dyslexia. I am thankful that today, students with a learning disability have access to programs that help to teach phonic alphabetic coding, visual recognition, fluency, and reading comprehension. These key ingredients provide tools for managing dyslexia, and in developing positive self-esteem to help deal with the struggles of dyslexia.

Dyslexia is why students tell their story to me. Their inner struggles are the same, but expressed in their own personal manner. The feelings they express encourage me as I continue to write my own personal story. Putting their feelings in writing gives them encouragement to overcome and move forward with their own life.

One may say, Yes, I am dyslexic. I am determined. I am passionate. I am intelligent. I am successful. I will surge forward with clarity. I have a purpose in life. Dyslexia won't keep me down.

Dyslexia is like a war that continually changes. I may win or I may lose. Failing my homework is like receiving an injury. Failing a test is like losing a soldier. Failing a final is like being taken prisoner. From time to time, I get pinned down under the spikes of dyslexia and go to the infirmary where I shut down. I try to build up my skills and fight back until dyslexia breaks its hold on me. I practice purposeful skills and continue to gain strength so I can defeat dyslexia's army. The war of dyslexia is far from over. I am gaining skills. I am getting better. I will win.

I am dyslexic. I watch my peers succeed. I want to be successful, too, and I dream of being smart. I study with determination and I hide the pain of dyslexia. I find my voice in stories and poems. I find laughter in my mistakes. I am dyslexic.

I have dyslexia and it's like a big bully on the bus. He follows me off the bus and bothers me while I do my homework. We are not friends as he is big and mean. I will stop the bully by working harder, asking for help, and staying after school for tutorials. I am trying to overcome dyslexia. I will never give up.

Dyslexia is like a lion trying to hurt me. When I read, the lion bites my skin and laughs at me. When I take a test, the lion confuses me by mixing up the words and making me feel dumb. The lion just laughs at me and it makes me sad. I want the lion to stop and go away.

I am dyslexic. I confuse the letters and jumble the words. I forget to focus and struggle with tedious tasks. I try hard but I feel different from my classmates. I feel stupid. I am dyslexic.

My dyslexia is like black darkness that you cannot see through. It goes with me everywhere and follows me like a shadow. It keeps me from seeing clearly when I read, write, or do math problems. It drives me crazy. I am learning defeating strategies to fight the darkness. Rhyming, coding, fluency, and spelling will help me to better grades. I will practice and practice my homework. I AM NOT ASHAMED OF DYSLEXIA.

I am dyslexic. Dyslexia changed my life. I had to let go of who I wanted to be and became who I really am. I have learned a great deal about myself because of dyslexia. I am determined. I am creative. I am confident. I am intelligent. I am dyslexic.

Dyslexia is like a deep black hole that sucks me down. The hole knocks letters and words around and frustrates me. The back hole gives me a headache when I try to keep the letters from moving around. I try hard to relax and read but the hole won't let go of me. I keep fighting back.

I have dyslexia and it has a loud voice. The voice is telling me, "You are dumb and stupid. You can't read." The voice goes off every time the teacher calls on me to read out loud. But when I use my strategies to read, the voice gets softer and softer, and I get stronger and stronger. As I work harder to learn, I get smarter and smarter. Someday, I will outsmart dyslexia and the voice will disappear.

I am proud of the students I met with the same reading disability that I have. I understand their struggles and their desire to achieve an education. On my own personal level, as I sit to write and write, the glitches in my spelling are still a part of me. It no longer bothers me because dyslexia has made me a stronger person with an unwavering drive to succeed. I can thank dyslexia for helping me to unbridle my dreams. With the Lord's guidance, may my dreams continue to soar strong with the winds of time. Part of my dream is to continue to help

young people understand they may have a reading difficulty but *it doesn't have them.*

On a weekly basis, Rocky and I visit my dyslexia friends in class just to encourage them. Just sitting in the classroom smiling and asking them about their day is a boost of encouragement. We talk about getting more physical exercise to declutter the brain and extra sleep to conquer the next day. We talk about what tests they are studying for. I watch the students as they complete their strategy work with the guidance of their dyslexia specialist, Mrs. Brown.

Of course, Rocky has to walk around the room and greet each student individually with a handshake. His presence makes them feel special. Mrs. Brown and many of the students think of Rocky as a lifelong friend as they remember when he was young.

Rocky developed quite a reputation with the students. One student in particular had the opportunity to watch Rocky grow from a playful puppy into a dog that could walk off leash in a crowed hallway full of high school students. Rocky and my student, Mitchell, became friends when Mitchell was in kindergarten. For thirteen years, Rocky and I would visit Mitchell on a regular basis to make sure his vision needs were met within the school system.

Toward the end of Mitchell's senior year in high school, Mitchell was recognized as an outstanding senior by the faculty at his school. Mitchell was chosen to be part of the school district's educational foundation "Hall of Fame" because of his integrity, leadership, positive attitude, and school spirit.

I was not surprised that Mitchell was nominated for this award, as he was a young man of sincere compassion and purpose. He understood the true meaning of humanity. Mitchell was not only intelligent and hardworking, but was creative and truly responsive to others. Before the age of eighteen, Mitchell co-founded a nonprofit organization to help persons in East Africa with albinism. Albinism is a deficiency of

the pigment melanin in the eyes, skin, and hair, which in most cases causes a pale appearance and vision problems.

Children born with albinism in East Africa are extremely vulnerable because they are being murdered and their body parts cut into small pieces and sold. The superstitious belief that body parts from a person with albinism can lead to power and wealth created a dangerous situation for these children.

Mitchell took this situation to heart and through his efforts and hard work raised thousands of dollars for the support of safe haven schools, medical care, and for sun protection for these children. Mitchell's clear action of purpose reached past East Africa as money was raised for albinism research at the International Albinism Center at the University of Minnesota in the United States.

After being selected for the Hall of Fame, Mitchell was then asked to select an outstanding educator that influenced his life.

An essay written by Mitchell in regard to his selected educator would be presented at a banquet ceremony. To my complete amazement, Mitchell chose me as the educator who had a significant impact on his school career. I was humbled to be chosen and was speechless when I read Mitchell's essay.

Mitchell started his essay by saying that he had many great teachers throughout his school years in our school district, some of whom he was lucky enough to have for more than just one year.

From the opening statement, Mitchell went on to say, "However, I doubt many students are able to say that they have been fortunate enough to have that special teacher since preschool." He stated:

> *"I can honestly say that Ms. Terry McMullin is one of the greatest influences for my success as a student. I have albinism and am visually impaired.*

T. A. McMullin

Ms. McMullin is my vision teacher through special services, but she has been much, much more than that to me throughout the years. Not only has she facilitated my necessary accommodations in the classroom, from enlarging print material to determining optimal seating, but she has also paired me with technology that has made a profound impact on my learning—something that I will certainly take to college next year.

She has been my advocate at every special services meeting and has drilled me on the importance of self-advocacy since preschool. Obviously, Ms. McMullin is wonderful at fulfilling her job description, but she doesn't stop there.

When I was in elementary school, Ms. McMullin often visited me during school to check on my progress and help me with adaptive skills. When she did visit, she frequently brought her dog, Rocky, which as you can imagine, was a great excitement to a classroom full of 4th graders.

When I was occasionally bullied by other kids in my class, Ms. McMullin was there to meet me at the principal's office with lightning speed. To this very day, I don't even know what magic she used to get there so quickly!

But whether it was playing with puppies in 4th grade or dealing with one of the more difficult experiences in my time in school, Ms. McMullin was always there through my most formative years, leaving an impact that I will never be able to articulate, much less reciprocate.

As I prepare to head off to college next year, I cannot image embarking on a new chapter of my life without her guidance and unconditional support. However, I know that because of Terry McMullin I am empowered to take on the challenges ahead.

For the rest of my life, I will forever cherish her kindness and benefit from the things she taught me. Ms. McMullin never let a visit or meeting go by without telling me how proud of me she was.

This is my opportunity to tell her how much she means to me. Words are insufficient to describe how grateful I am to have her in my life. Over our twelve plus years together, Ms. McMullin has always referred to me as a "prince" and I have tried my best to live up to her nomenclature, but today it is my honor and pleasure to tell you that it is she who has been the "Queen of Hearts" all along!"

After reading Mitchell's essay for the third time I was reminded of the prayer that I prayed over fifty years ago.

Lord, I want to be what You want me to be...
I want You to be proud of me...
Lord, help me walk through the valley so low to the top of the highest hill.
Lord, I want to travel the journey You set before me.
Please hold my hand and help me to live in the center of Your will.
I need You, Lord, and I want You to be proud of me.

I know deep inside that the Lord is proud of me and that I am living in the center of His will. In looking back, the Lord had carried me to the top of the hill to live a life of compassion and purpose.

Chapter 23

A Word for You

LIKE THE SHIFTING OF THE WIND, bad news can change the rhythm of your heartbeat. Rocky developed a cough just like that of Fifi. The cough was sudden and I knew deep inside that the result would not be what I wanted to hear. Rocky was at the veterinarian undergoing X-rays and ultrasounds to determine the cause when I received a call from the vet.

I remember the words, "Terry, the news is good and bad." Rocky has a tumor in his left kidney, which could be removed, however, the cough is a result of the cancer which has spread to his lungs."

My heart sank and I replied, "It is not fair to let him suffer. When can I come say goodbye to my boy?"

"Let's meet at five o'clock this afternoon," the veterinarian said.

I sat in my office and said, "Thank you, Lord, for sending Rocky to be by my side, surgery after surgery, for a loving companion to ride horses with, for a faithful dog who has encouraged so many people. Thank you for my canine soul mate that sat next to me, licking the tears off my face, when I had to put Zandy to sleep several months ago. Thank you, Lord, that Rocky will not suffer with this dreaded disease."

I had thought in the past "How am I going to handle losing Rocky? How will I tell his friends that loved him so much, what would I do?" The time came suddenly and all I could do was shift into crisis intervention mode and move forward. I had two hours to contact the

teachers and colleagues that knew him and loved him as much as I did.

Thank the good Lord for email and text messaging. I absolutely could not speak to anyone without letting out the hurt that came from deep inside my gut. I knew I would not be able to talk. I sent messages to ten of Rocky's friends and within one and a half hours they all stood in the veterinarian's examination room to say their own heartfelt goodbyes.

Rocky went to each one of his friends—one by one—to give them a kiss and a wag of his tail. Goodbyes and I love you were filtered though the tears and hugs. When he was working, Rocky always wore a bandana around his neck. He had a dozen bandanas and it seemed most appropriate for each of us to hold and to keep one of his personal bandanas. I used mine to wipe away my tears. We all stood together and agreed that this was the time to say the last goodbye.

News filtered around the school district, and the students that Rocky saw two days before were absolutely devastated. The principal cried, the teachers cried, and students cried. I had to gather up the strength to not let them see my tears. Cards and letters, donations to the local vet school and animal shelter were given by Rocky's friends in his memory. Rocky proved that a dog with unconditional love does make a difference.

One of my other therapy dogs, Gracie, played a huge role in helping to heal the massive pain of our loss as she daily visited with the students. Finally, Gracie put a smile on our faces and mending in our hearts. It took two weeks of visiting with the students, encouraging them to journal about their sadness, before tears were replaced with laughter. I sat amongst Rocky's student friends and talked about writing from the heart, putting their thoughts, their hurts, their frustrations, and their times of celebrations on paper. I told them, "It's your journal, your journey, your spelling, and your punctuation. It is from you to you. Write what's in your heart."

Together we sat and wrote from the deepest chamber of our thoughts. No one questioned what the others were writing. This was a group exercise in private writing.

After I finished writing, one student asked me if I felt better. I told the class that sitting there with all of them made me feel better. I did not share my writing out loud but I folded the paper, *A Word for You,* and left it sitting on the table.

A Word for You
From adversity comes strength
From strength comes success
From success comes accomplishment
Be proud of who you are
Your hopes, your dreams, the calling in your life
Journal your life, your story
Break through the roadblocks
Stay focused, and ride forward

Through it all, you will gather the courage to live with compassion and purpose.

My heart further mended when a new Border Collie was introduced into my life. I adopted Katie Lynn seven weeks after I said goodbye to Rocky. She was a special friend sent to show that life may be tough but with great courage you can make it.

Katie was severely hurt in a tornado a year before Rocky passed away. Katie became lost when strong, brutal winds, and hailstorms raced through the skies over her Oklahoma home. She became a victim of the devastation.

While emergency and rescue workers combed through the rubble searching for victims, Katie was left hurt and wandering helplessly for weeks before being rescued.

While searching for food and water, Katie was shot in the abdomen for simply looking for a safe place to rest. Eventually, she was picked up and placed in an animal shelter. Katie lost her hearing and was totally deaf. Her left ear, pelvis, and several ribs were broken. There was a bullet embedded in the right side of her body and she had a mouth full of broken teeth that were infected.

The state of Oklahoma required that animals left homeless from the tornado be placed in a shelter for a four-month period of time before they could be adopted. However, money was not provided for the care of these animals.

Katie remained in the animal shelter for four months with minimal treatment. Her teeth continued to get worse, the bullet remained in her body, and no one claimed her. It seemed like she was waiting out her four-month death sentence.

Because of an act of kindness, life turned around for Katie. After completing her stay in the shelter, Katie was released to the All Border Collie Rescue and placed in one of their foster homes in Oklahoma. The rescue immediately began to provide the medical attention she desperately needed.

As with most foster homes, children or animals are not part of the permanent family and they are often moved from home to home. So within the rescue, Katie went to a foster home located in Texas. Her new foster mom, Shirley, provided emotional healing, unconditional love, and care for Katie on a daily basis. Because of Shirley's compassion and purpose, over time the efforts paid off and Katie became a healthy dog.

Katie learned to communicate with her eyes so Shirley taught her sign language for come and stay. Katie and Shirley proved to each other that unconditional love does make a difference.

It was the right time and the right place for me to find Katie and to open my home to her permanently. I made the same promise to her

as I made to Rocky and the others. "I promise to love you and to see that you are never hungry or thirsty. I promise to take care of you and provide you the best home I possibly can. Your new home will be forever and you will never have to worry about being sent away, mistreated, or hurt. We will love each other, walk through the pasture together, go places and just have fun," I looked deep into Katie Lynn's eyes and added, "When the day comes that you can no longer continue with a good quality of life, I promise I will hug and kiss you and stand by you to say goodbye. I will not ever let you suffer."

Katie Lynn has a story to tell and she will be an encouragement for overcoming struggles and obstacles. Just like each of us, Katie's life has been a journey itself. She will never walk in Rocky's paw prints, or wear his bandana, and she can never take Rocky's place, but she will leave her own story in the hearts of the friends that she meets.

As I continue to work on my writing and my journey, Katie is sleeping in Rocky's bed. She has a special place in my heart as I see a dog that is thankful for unconditional love and security.

Deep down inside, I understand being in a foster home, the fear of being placed again and again in another home, the adjustments it takes to live with strangers, and the courage it takes to survive. I fully comprehend the courage it takes to step out and make a way in life and to set and achieve goals.

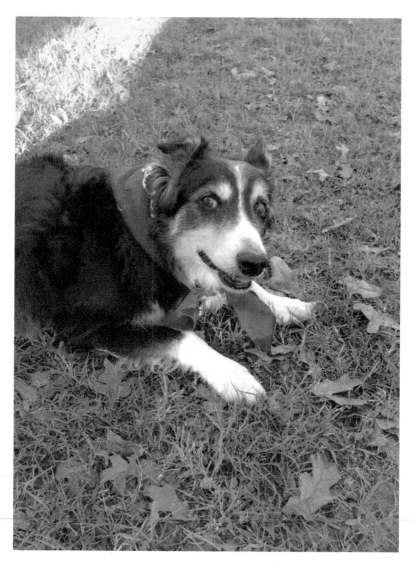

Katie Lynn McMullin
T. A. McMullin

Chapter 24

Writing from the Heart

DAILY, I CONTINUE TO WRITE from the heart. Perhaps someday, my life story of *Gathering Courage* will inspire others to write from deep within and encourage others to be the best they can be. To live a life of compassion and purpose is the true meaning of life.

We all have a journey—past and present—a journey that draws us closer to God or pushes us away. *Gathering Courage* is my journey, one of struggles and triumphs, bending and breaking, molding and reshaping.

See how the extended hand of God shadows and protects the growth of a tender, innocent child with love, grace, and mercy. As a young child, I found myself alone on a dusty road different from any other in my family. It was a road filled with twists and turns interlaced with lessons that would forever change me. God himself knit me in my mother's womb and called me his precious, beautiful child. He is the great Father I never had. He is the truthful brother that provided me with strength and courage to conquer a reading disability. Being held safe in the hand of God, I began to know that He loved me.

Many lessons were taught to me as I walked the difficult path of my childhood. During my journey from an orphanage to success, I can assure you that Jesus walked every mile of my trials and triumphs. He never left my side. The Lord didn't abandon me as an illegitimate orphan child. He did not leave me in a crib in an orphanage home; He stood over the crib and made sure I was fed and rocked. He did not call me stupid. He never left me with my luggage at the doorstep

of a foster home; He stayed with me every moment to make sure I was safe. He did not leave me during my surgeries, but guided the doctors as they performed surgery after surgery. He picked me up, blew strength back into my life, and gently placed me down so I could ride horses again.

As my trust in God grew, I learned that the extended hand of God delivered the best lessons in life. These painful lessons worked within me to produce a peace that passes all understanding and gave me the security to know that with Christ anything is possible. It is through Jesus Christ that I am what I am today.

Allowing God to be God provided the rich ground for the roots of my inheritance to take hold. Anchors of trust deepened as His nurturing love and encouragement penetrated my inner parts, promoting growth that developed an inward strength beyond measure.

God wants His children to encourage others as He encourages us. "For I know the plans I have for you," declares the Lord.

"Plans to prosper you and not to harm you, plans to give you hope and a future. Then you will call upon me and come and pray to me with all your heart." (Jeremiah 29:11)

The Lord wants us to share our hope and our future to encourage others. Each of us can share words and deeds of kindness to help encourage the lives of others right where we live and work. Life at its best is tough, but together we can make a difference and endure the hard times together.

Writing your story about your journey through life will help you find hidden treasures like gratitude, strength, and courage. I think you will be surprised how much healing you will receive when you actually put pen to paper and recall all of life's events. Healing from the inside out will surface as you write. Healing produces internal peace, a wonderful gift that God freely gives to each of us.

We are all growing in the Lord. I look forward to hearing your life story, your journey, and how God has walked beside you. He rides with us through the rough terrain of life.

Be safe. May your horse never buck, and your saddle never slide. We don't know what's around the bend of the trail. There will be valleys and mountaintops but remember, my friend, you're not riding alone. It is okay to grab hold of the saddle horn and hang on until the crisis has passed. Sit up straight and tall in the saddle, keep your eyes focused forward. May the good Lord find you faithful. Until the sun sets on your life, enjoy the journey. Eternity is somewhere around the bend.

God said that everything would be all right if you just hold His hand. Reach out today. Give Him your hand and hold tight, knowing that your grip is secure in His hand. He will be your friend until the end.

Journal your hardships, pray, and watch how God blesses you. Look forward with anticipation as to how God shadows and protects your growth.

T. A. McMullin

Gathering Courage Media

GatheringCourageMedia@gmail.com

GatheringCourageMedia.com

Acknowledgments

FIRST AND FOREMOST, praise and gratitude goes to my Lord and savior Jesus Christ for the many blessings bestowed upon me. I never dreamed that years of journaling, gratitude, and writing notes on a napkin would lead me on a journey to write and produce a book. To my complete amazement *Gathering Courage* became an award-winning book in less than 30 days after printing the proof copies.

God truly orchestrates our paths and puts people in our life intentionally. I am grateful for my friends that God sent my way because they have blessed me beyond measure. Every person in life needs a cheering section, a group of people who love us, pray for us, and encourage us to be the best we can be. I am blessed beyond measure.

First, I must thank Mrs. Edna Gladney for living a life of compassion and purpose. My life is better because of you. Although you are long gone, your compassion for orphans and your courage to make the welfare of unwanted children the focus of your 'life mission' will live on forever. Mrs. Gladney, you made a difference in my life and gave me a place to call home.

To my departed friends and grandmother who loved me unconditionally. Your unconditional love and guidance changed the trajectory of my life. Without you, I would not understand the power of living a life of compassion and purpose. My hope is that the love and guidance you gave to me can be passed on through the words of this book.

Thank you to each of my friends. I love you dearly. From the very beginning of my friendship with each one of you, I knew you were my family.

Karlyn, your gift to organize words into beautiful sentences is a gift, a talent that compliments you perfectly. You are truly a woman of words and meaning. Thank you for being a great writer, a collegiate, an encourager, and most of all a friend. You have always been around to help me when I needed help the most. You helped turn the stressful times in my life into a successful adventure. I can't thank you enough for helping me to draw the words out of my heart and placing them on paper.

Skip, you kept me on track with my burning desire to help others to make their life better. Your steady encouragement and patience proved to be strong and powerful. Thank you.

Maryanna, you guided me even further on my journey "To Make Life Better." Please know I appreciate you.

Bobby and Angela, you launched "Gathering Courage" into completion. This was part of God's plan for the mission, "To Make Life Better." Thank you.

Dr. Laurie, your compassion for animals and their owners is why you are loved so much. Thank you for never being too busy to help when my animals were in need especially the night my horse, Zandy, needed you the most. It is with tears in my eyes that I say you are loved.

Sally, thank you, for sharing your love of the Indian country and the great outdoors with me. Seeing Dubois and Cody, Wyoming from the back of a horse with you was the greatest time of my life. Your pictures help my story come to life. Thank you for allowing me to use your pictures.

Robin Susan, your friendship to this very day remains invaluable to me. You were the strength in the wind to help me get through Texas A&M University.

Joan, from you I learned that compassion is a lifestyle and part of the thought process on a daily basis. The compassion that shines through you is contagious.

Linda, you and Walter always treated me like I was part of your family. Just knowing the feeling of belonging is something I will never forget. Thank you for loving me as if I was your own.

Ann, if only you and I could saddle up our best horses and turn back time a hundred years. We could ride forever across the land we love then unsaddle and go sit on the front porch of the old house when it was new. As the stars settled in we would say, "This is the way life should be." The hours spent riding horses and the last cattle drive with you will forever remain in my mind. There will be another big round up in heaven and we will both be saddled and ready to ride.

Molly, I absolutely don't know what I would have done without your kindness and concern after an unbelievable automobile accident. You helped me to turn a tough situation into triumph. The good Lord knew that I needed you and your strength. I am a better person because of you.

Nancy, thank you for helping me unload horse feed when my shoulders were so badly bruised and sore from my accident. We walked the halls of the university together, went through the same educational department, and did not know each other until we became colleagues. What a gift you have for working with people.

Lisa, Rocky loved coming to your class from the time he was a puppy. He loved you and together the two of you helped so many students to overcome their fear of reading. Reading is the true pathway to success. You and Rocky were on the same pathway. Thank you and Tom for sharing your children with me, I love them dearly.

LaBridget, you are a prayer warrior. What an honorable gift to be given. Thank you for your prayers and words of encouragement. Your dyslexia students are better individuals because of your teaching style and encouragement. I am so proud of you.

Anne, you and Richard are so appreciated by me. I appreciate what you do for me and especially for my animals. My animals think that you are their second mother. I can still hear Jubilee braying when you drive down the driveway. He is letting me know that his "Momma Anne" is here. You and Richard are great stewards of the land and your act of kindness makes my life so much easier.

Becky, I will always remember Rocky taking great delight in running down the hallway to your office and jumping in your lap while you were on the phone. He loved you so much. Thank you for your thoughts and guidance as I spent three long years following my passion to help others and to pursue this project to the end.

Robin B., your office door is always open and you are never too busy to collaborate in meeting the needs of your students. Your gift to serve others changes the lives of those you work with.

Lana, we are kindred spirits. I remember when you stopped what you were doing to come to my house to shave Zandy. Zandy was suffering from Cushing's disease and the Texas summer heat of 115 degrees was so hard on him. You came and helped shave the long hair off of his body so he could make it through another summer. Thank you for never being too busy to come to help me.

Wray, Gwen, Wrandy, and Kathy - Each of you exemplifies unconditional love. Love is the greatest calling by God. Thank you for loving me and being part of your family. I love each one of you so much.

Jenny, Jim, and Shirley - I appreciate your unconditional love for the Border Collies. Each dog that comes across your path becomes better

because of you. Katie Lynn is happy because of your unconditional love and care.

Misti, thank you for taking the cover picture of Sonny and me. Your talent captured the moment. Thank you for sharing your precious boys with me. It thrills my heart to see little Gus standing next to Marty Joe, my 1,200-pound horse, with no fear. I can't wait to share my love for horses with your boys.

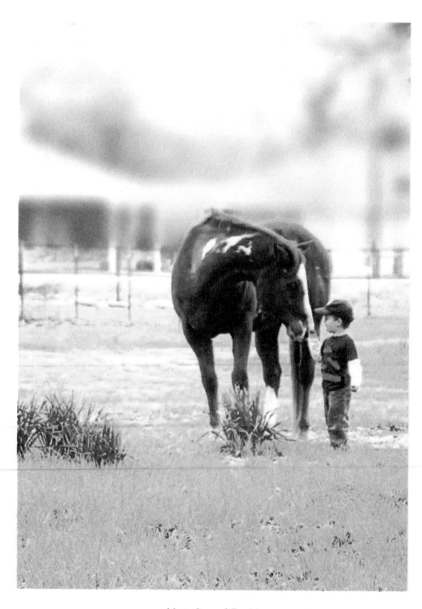

Marty Joe and Gus Moser
Misti M. Moser

About the Author

THE AUTHOR, T. A. "TERRY" McMULLIN knows as well as anyone that hard times are a part of the journey of life. During Terry's journey, she was an orphan, an adopted child, and then made a foster child by her parents. Terry learned how to turn rejection into success as she struggled with a reading disability.

As a child in the 1960s, hardly anyone understood the struggles of dealing with dyslexia. But Terry turned her struggles with dyslexia into strengths as she taught herself how to read and study while working her way through college.

Terry received a Bachelor's and Master's degree from Texas A&M University while becoming a teacher and a writer.

Terry's life transformed from a broken-hearted child who could barely make out words in elementary school to a teacher who encourages young people to work hard and achieve their greatest aspirations.

At crucial points in Terry's life, she found people who cared and understood, who became her encouragers. The encouragement from others made Terry's life better so she vowed to be a champion for others who needed help.

Terry gained great gratification and emotional even spiritual support from working with animals, horses in particular. This loving pursuit

continues today as Terry lives on a small ranch in Texas with her horses, donkeys, and rescued Border Collie dogs.

Everyone who loves animals will be inspired by the great stories of our animal friends who helped Terry to conquer mountains of challenges and to celebrate the joy of success.

People who are dealing with the hardships of life will understand Terry's story. They will become inspired to work hard to achieve their own personal goals.

Children in orphanages or foster homes will know that, despite the reality of personal rejection, they too can become successful in life.

The writing of *Gathering Courage* was a three-year project of reminiscing from the heart and hurts of the past for the sole purpose of encouraging others.

What started as a thought then words on a napkin set the dream in motion to form sentences on paper. The dream grew and the formation of a book developed into a purpose, a mission - "To Make Life Better."

In less than 30 days after printing the proof copies, *Gathering Courage* became an award-winning book and T.A. McMullin became and award-winning author.

2015 North American Book Award
1st place winner – Animals/Pets
1st place winner – Biographies, Autobiographies, and Memoirs

2016 Readers' Favorites 5 STAR Award
2016 Readers' Favorites International Book Award
2016 Best Book Award

2017 Enduring Light Medals Award
Silver Medalist Winner – Christian Thought
Exemplary Christian Themed Book
Enduring Message

Sally J. Wulbrecht

"Gathering Courage to make life better,

to work hard to follow your *dreams,*

to invest in yourself and others,

to *encourage* others to be their best,

will make life *better."*

T. A. McMullin

Thank you for reading about my journey
and becoming part of my mission –
"To Make Life Better"

The window of opportunity is open for the messages

in *Gathering Courage* to inspire others.

Together we can make a difference.

2017 Enduring Light Medals Award

Silver Medalist Winner – Christian Thought,

Enduring Message

"Shining a light on exemplary Christian books!"

Encouragement puts love in the heart and direction in the dream.
Encouragement and kindness does make a difference,
I know it did in my life.

T. A. McMullin

GatheringCourageMedia@gmail.com
GatheringCourageMedia.com

What Readers Are Saying About
Gathering Courage

"*Gathering Courage: A Life-Changing Journey through Adoption, Adversity, and a Reading Disability* by T.A. McMullin is the author's **incredible memoir** describing her journey, the endless challenges she had to face, and the people that touched her life along the way.

"Without anyone she could fully count on to be there for her unconditionally, she learned to turn to God at a very early age and to be self-reliant. But no matter how many misfortunes and challenges she faced, which were endless, she never gave up on her dreams. With a few acts of kindness offered to her along the way, **Terry went on to travel one of the most inspiring life journeys.**

"There are many lessons to be learned from Terry's struggles and her never-give-up attitude. Her journey sends a strong message; **no matter how many times life beats you down, get up and fight back**; yes, the tough times will keep coming but as long as you have not given up, you have not lost the fight. And always turn to God and trust Him to guide you through even your darkest hour.

"Her story also honors the **selfless heroes** that open their hearts and touch the lives of others; your **kindness is not in vain** and Terry's story is true testimony to this. *Gathering Courage* **is a truly moving read that will touch many hearts and positively inspire them to touch the lives of others.**"

***** *Faridah Nassozi - Uganda*

"Any reader who loves **a true story with a Christian focus** about a person that was able to achieve a great deal through their own **hard work** and **perseverance** should definitely read this book.

"Adopted as a young child, then placed into foster care at the age of nine because she continued to struggle with learning disabilities, the author's journey is one that will both break your heart and convince you of the **power of the human spirit**. The story of the author's journey from a **broken hearted little girl to a dynamic and successful woman** with a **passion for helping others is a true inspiration**."

***** *Tracy A. Fischer - Wisconsin*

211

T. A. McMullin

"This is one inspirational novel. I loved reading about her life and her struggle. People like her give me **hope that there is something for all of us in this world.** Her hard work, her ability to cope with hardships, and her determination are very enlightening and interesting. It is truly amazing how she is **a teacher** right now and **changing the lives of people around her.** The way she writes is moving. You feel an instant connection with her. After reading this book, I feel like I know her. If I ever meet her, I would give her a warm hug, because it is **people like her who make changes in this world and help others.**"

***** *Rabia Tanveer - Pakistan*

"T.A. McMullin takes the reader on an emotional journey... Follow Terry as she shows determination and a desire to learn as she teaches herself how to read, and see how she transformed her life and became a teacher. **It is not often you get to read a story such as this, a story that is real life and truly inspirational.**

"T.A. McMullin has written a wonderful story that flows well with the prose, but is also such **an inspiration it will make you laugh, cry and want to do better.** It makes **you want to look at your life** and wonder why you haven't gone further (in a good way) and done more. This is a truly wonderful and inspirational read and I recommend it."

***** *Kathryn Bennett - Indiana*

"*Gathering Courage* is all about **overcoming adversity and striving for success.** I was amazed at how much Terry really went through in her life and still managed to stay strong and brave. I would definitely be proud to have a friend like her, going through the things she did and never giving up.

"This is a **story that can help other people** because there are a lot of people out there, suffering in homes where they feel unloved or unwanted, but that doesn't have to define you. The boundaries and limits other people set are their limits, not yours, and Terry proved that throughout her life. I would definitely **recommend *Gathering Courage* by T.A. McMullin to anyone who's feeling lost in their own lives.**"

***** *Samantha Dewitt (Rivera) - Michigan*

***** **From One Aggie to Another** *****
"This book is **an absolute must read.** Once I started reading, I couldn't stop. Terry's story spoke to me on so many levels. From her burning desire to be a fightin' Texas Aggie, to her constant search for God's will in her life, I was glued to the pages. **A very powerful and moving testimony.** Well done good and faithful servant. Gig 'em, my friend! WHOOP!!!"

Lesa – Texas A&M University – Class of '85
College Station, Texas

212

CPSIA information can be obtained
at www.ICGtesting.com
Printed in the USA
FSOW03n0350030217
30319FS